IMAGES
of America

LETCHER COUNTY

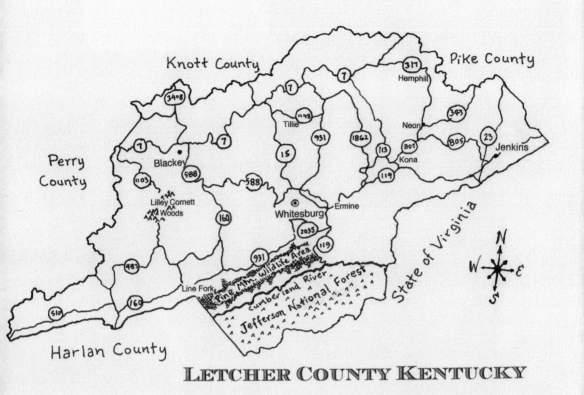

This rendering of current-day Letcher County is by J. Gregory Cooper, MD.

IMAGES
of America

LETCHER COUNTY

Deborah Adams Cooper

ARCADIA
PUBLISHING

Published by Arcadia Publishing
Charleston, South Carolina

Printed in the United States of America

Library of Congress Control Number: 2011920418

For all general information, please contact Arcadia Publishing:
Telephone 843-853-2070
Fax 843-853-0044
E-mail sales@arcadiapublishing.com
For customer service and orders:
Toll-Free 1-888-313-2665

Visit us on the Internet at www.arcadiapublishing.com

Lena Jean Addington Adams
(1929–2010)

To my mother, who taught
me courage and grace.
To my father, who gave
me a love for words.
To Gary and Kim, my first
Letcher County friends.
To the loves who sustain
me—Greg, Matthew,
Anna, and Erin Cooper.

CONTENTS

ACKNOWLEDGMENTS

Letcher County would not and could not have been possible without the help of people and organizations who cherish the past and work to preserve it for the future. Letcher County Historical Society (LCHS) has published *Letcher Heritage News* semiannually for over 20 years to this end. Thank you to Creda Issacs and all who have volunteered their time and energy to this great organization.

Brian K. Caudill, who established the LCHS web page, is relentless in his pursuit of the county's history. Thank you Brian, for your patience in answering many emails, proofreading, and sharing your extensive knowledge of Letcher County's history with me. Your help was invaluable. I am especially grateful to Lee Anna Mullins, who drove me around the county in search of photographs and people with stories. You made me feel so welcomed. To Don Woodford Webb, whose love for his hometown is inspirational, I thank you for many answered questions and for directing me to people who were of further help. I am indebted to Bennett Welch, who has invigorated the past with his "Moments and Memories" column in the *Mountain Eagle* and who researched dates and specifics for me.

Thank you Phyllis Ann Hall Adams, Linda Adams Collins, and Susan Day Brown, for going above and beyond to accommodate me and to Anne Caudill and Diana Caudill Grace for a delightful afternoon of remembrances.

To my friend Shonda Judy, I thank you for a great job photographing present-day Letcher County.

To my editor Amy Perryman—my own personal cheerleader—thank you for your patience and for sharing words of comfort during a particularly difficult time.

Special thanks go to the many people who opened their homes to me, shared their valuable photographs, and more importantly, shared their precious memories. These stories might never have been recorded except for their generosity.

Lastly, to my husband, Greg, and my family. I love you. You are my biggest fans. Thank you for helping me to believe that my hard work would one day be an "accomplishment."

INTRODUCTION

Letcher County was formed from sections of Perry and Harlan Counties in 1842. It was named for then-governor Robert P. Letcher, who was Kentucky's 15th governor and a strong supporter of the Whig party. The county lies within the southeastern coalfields and is bounded by Harlan, Perry, Knott, and Pike Counties in Kentucky and by Wise County in Virginia.

There is evidence that a prehistoric culture existed and thrived among the hills of eastern Kentucky from around 800 BC to about AD 500. These people would have been the first of many generations to discover the riches of the wooded Cumberland Plateau. These Mound Builders, as they are called, survived on seed grasses, nuts, wild fish, and game. By the early 1700s, descendants of these prehistoric people—the Shawnees, Mingoes, Choctaws, and Cherokees—lived off the bounty of the land, but none permanently settled in the region.

It was likely that 17th-century European fur traders explored Letcher County, with land company surveyors to follow. In 1750, Dr. Thomas Walker, a Virginia physician and explorer, led a party of adventurers through Cumberland Gap and into southeastern Kentucky. This new passageway through lower central Appalachia would become the principal route for westward migration for the next half century. Daniel Boone and his party of Long Hunters would later widen the gap to allow for wagons.

Daniel Boone most certainly would have been in Letcher County in June of 1774, when he and Michael Stoner traveled to the Kentucky bluegrass to warn surveyors of the impending war, known as Dunmore's War. This war between the Shawnees and Mingoes against the British Colonial militia is considered by some to be the first battle of the Revolutionary War (1775–1783).

Daniel Boone, his wife, Rebecca, and their family spent much time in what, in the 1790s, would become Letcher County. They hunted for bear during the winters near the headwaters of the Big Sandy. The family would then render the bear fat into oil to sell.

The Pound Gap, which is located on the county's eastern border with Virginia, proved another strategic entryway for early pioneers. By 1806, almost every important creek had attracted settlements. By 1810, there were over 100 families living in Letcher County.

Whitesburg, the county seat, was the only actual town in Letcher County until the advent of the railroads in 1911–1912 and the building of the coal towns. Whitesburg was named in honor of John Daugherty White, a Clay County politician who had lobbied tirelessly for the creation of Letcher County. White was a member of the Kentucky state legislature twice, a US representative from Kentucky, and a delegate to the Republican National Convention in 1880.

When Richard Broas, a prospector by trade, discovered coal samples along the Elk Horn Creek while serving as a captain in the Union army, he knew he had to return to eastern Kentucky after the Civil War to investigate. In 1883, Broas returned to Letcher County to discover what he called "the best coal in the United States," the Elk Horn vein.

From 1903 to 1905, coal companies, such as Consolidated, Elkhorn, and Southeast, bought up the mineral rights of Letcher County landowners. These landowners ceded their mineral rights under what is known as the "broad" or "long form" deed. The moral, ethical, and political implications of this practice are still actively debated today.

The large coal concerns began tunneling through mountains and building trestles and bridges to reach and open up the vast but isolated coal fields. By 1920, with the exception of Whitesburg, the majority of communities in eastern Kentucky were built expressly to house the miners and employees of the coal companies. Many of these towns took on names associated with coal and fuel: Carbon Glow, Neon, Blackey, and Hot Spot. William T. Cornett states in his 1984 *Letcher County Kentucky: A Brief History*, "The coming of this railroad was probably, when coupled with the building of the coal camps, the most dramatic occurrence that this county has witnessed up to the present."

The Consolidated Coal Company constructed the town of Jenkins in 1911 as a classic company town built to the finest standards; it was promoted as a model mining community. The city was named after George C. Jenkins, of Baltimore, one of Consolidated Coal's largest investors. By 1913, of the 1,000 homes built in Jenkins, 200 were regarded as the "best built anywhere." They had features never seen before in the remote mountains of Appalachia: fireplaces, pantries, porches, electricity, and by early 1920, most of the homes in Jenkins featured running water and sinks.

Consolidated Coal built its mines with state-of-the-art equipment, electric lighting, and massive ventilation systems. The company built hospitals and schools and brought in doctors, nurses, and teachers. They provided employee medical insurance, which covered disability. Elkhorn Creek was dammed, and a 15-acre lake was created for fishing, boating, and swimming. And the company paid its miners wages above the union scale.

Before World War I and with the coming of the railroads, came an influx of European immigrants looking for work in this time of prosperity. In Letcher and surrounding counties, the work of Italian stonemasons still exists in the exquisite stone artistry of bridges, building foundations, houses, retaining walls, and, most notably, in churches.

After 1913, eastern Kentucky became the state's leader in coal production. In 1929, two years after the boom ended, the stock market crash caused a one-third drop in production. Like many coal towns in Letcher County, Jenkins reached its peak at midcentury and began to decline during the 1950s. World War II temporarily boosted coal production, but by the late 1940s, coal prices dropped. In 1956, Consolidated Coal sold all of its properties to Bethlehem Steel.

One

THE BUILDERS

Before World War I, thousands of Eastern Europeans immigrated to the United States, looking for work. Many of them sought work in the coal industry of southeastern Kentucky, southwestern Virginia, and West Virginia. Some coal companies hired only white, American-born laborers, but Consolidated Coal, Elkhorn Coal, Inland Steel, and others employed local workers, African Americans, and European immigrants. (Photograph by Shonda Judy.)

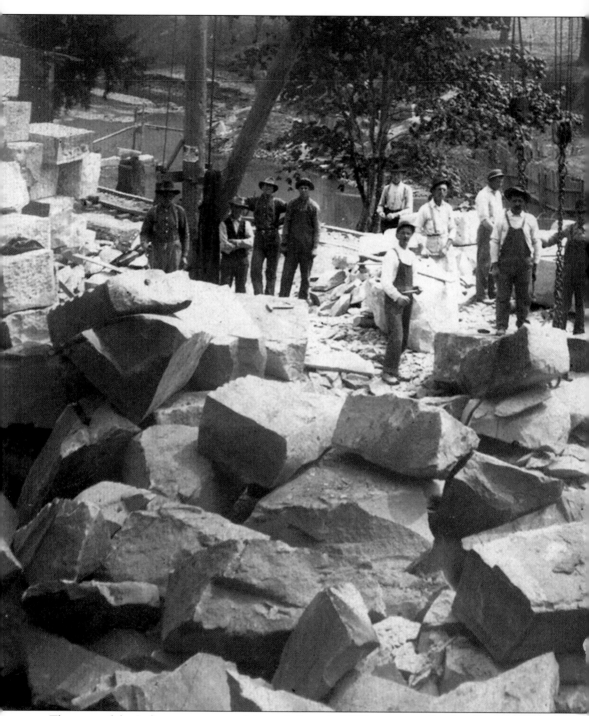

The story of the Italian stonemasons (pictured above in 1910) coming to Letcher County must be told along with the story of the railroad and the growth of the coal industry. When Giovanni Palumbo, Domenico Mongiardo, Francesco Mongiardo, Giuseppe Romeo, Augusto Cotispoti, and Alfonso Policetti came to Appalachia in the 1910s, it was to build bridges for the Louisville & Nashville Railroad Company (L&N). The company had paid for their passage to America,

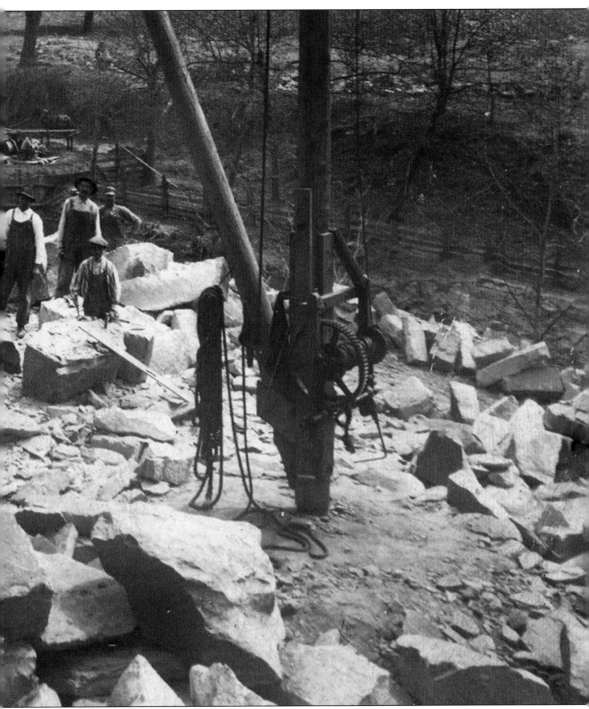

and because of Italy's poor economy in the early 20th century, the immigrants were eager and delighted to find employment. They brought with them a culture and a sensibility that had not been experienced by the English, German, and Scotch-Irish who had settled this land, surviving by farming and building basic designs of timber and logs. The Italian immigrants would change this. They would build with stone. (Courtesy of Patty Majority.)

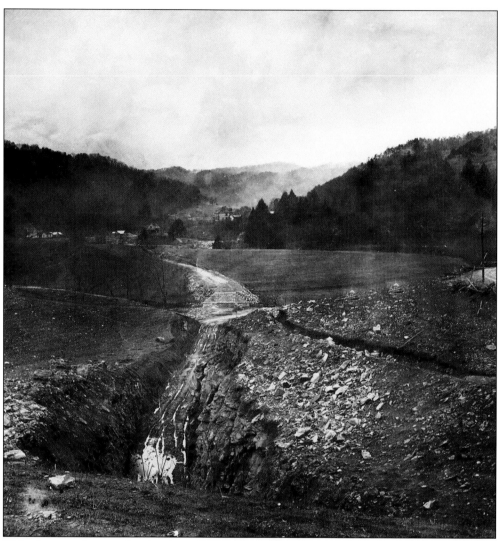

This photograph was taken in about 1909 and could be the site of the first bridge built by the stonemasons for the railroad. It is atop what is now known as Tunnel Hill. Looking westward, toward the center of Whitesburg, the house in the distance is believed to be that of James P. Lewis. Tunnel Hill got its name from the tunnel (pictured during construction) the Louisville & Nashville made to ensure more efficient rail transportation. This was necessary in Appalachia to avoid trains traveling up and down mountains. (Courtesy of Sheila Swisher.)

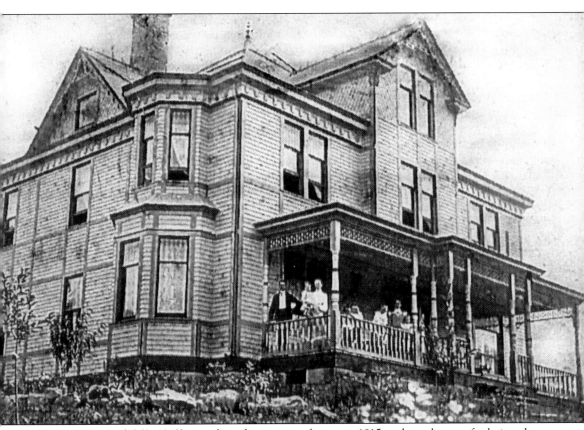

James P. Lewis (1869–1942) was elected secretary of state in 1915 and was known for being the only Republican elected to statewide office that year. He was a native of Letcher County and was superintendent of schools from 1892 to 1897. Lewis, his brother Martin "Mart," and many other Letcher County merchants in the late 1800s discovered that the railroads were opening up southwest Virginia in search of timber and coal and to offer passenger service. After all, this was 20 years before the railroads would come to Letcher County. Merchants and farmers began hauling mule teams loaded with their extra farm produce, moonshine, and animal hides to barter for sugar, salt, coffee, and dry goods brought in on the trains. Scuttle Hole Gap was the shortest route across Pine Mountain from Whitesburg to the newest coal camp in Stonega, Virginia, and the rail. (Courtesy of Leigh Lewis Blankenbeckler.)

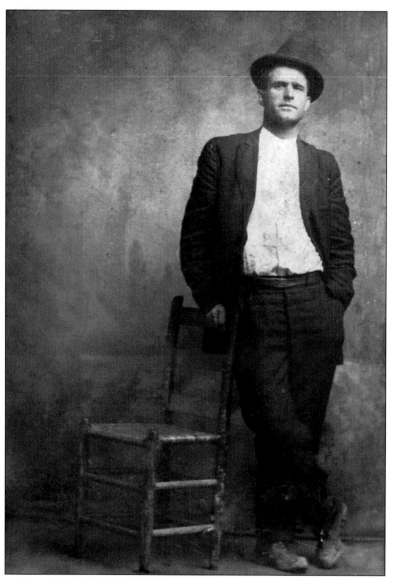

A 50-year-old Francesco Mongiardo Sr. casually poses for a photograph. According to Kentucky lieutenant governor Daniel Mongiardo, in 1915, when his grandfather Domenico and his great-uncle Francesco came through Ellis Island, the two brothers were separated into two different lines to be processed. They, like most immigrants, spoke no English, and the Ellis Island clerks spoke no Italian. Domenico was processed with his last name intact. Francesco's familial last name, Mongiardo, however, must have been interpreted by the clerks as Majority. The names have remained the same with one branch of the family known as Mongiardo and one as Majority. Domenico Mongiardo's passage to America had been paid for by US Steel. The company sent him to Hazard, Kentucky, or "Esser," as he said, to work towards paying back his debt. The Mongiardo surname is still well known in Perry County. Mongiardo's son Jimmy owns and runs Mongiardo liquors in Bulan, near Hazard. His son Daniel, who tells this story, is a physician and politician living in Hazard, Kentucky. Francesco, anglicized to Frank, was sent to Leatherwood, Kentucky, to repay his trip to America. He fell in love with Ollie Fields, a girl from Little Cowan. Frank Sr. married her and moved to Letcher County. (Courtesy of Patty Majority.)

14

Giovanni (anglicized to John) Palumbo Sr. is pictured above next to his wife, Della Howard, who is holding their baby, John Palumbo Jr. The two young girls on either side of the chair are two of Alfonso Policetti's daughters. Palumbo was the only formally trained stonemason to come to Whitesburg. At nine years old, Palumbo apprenticed as a stonecutter and carver near Castel San Giorgio in the Campania Region of southern Italy. In 1902, at age 16 and penniless, he began work in Pennsylvania for Consolidated Coal Company, which had paid his fare to America. Palumbo met Alfonso Policetti while both worked for the L&N railroad. They built stone foundations for bridges and tunnels used by the rail lines to haul coal from the West Virginia coalfields. In 1908, these two men were joined by Francesco and Domenico Mongiardo, Augusto Cotispoti, and Giuseppe Romeo. According to Justine Richardson, the Appalachian region to which these young immigrants came, and stayed, is remarkably similar to their home in the Calibrian Mountains of southern Italy, and both regions had a coal mining industry. (Courtesy of Kathy Palumbo.)

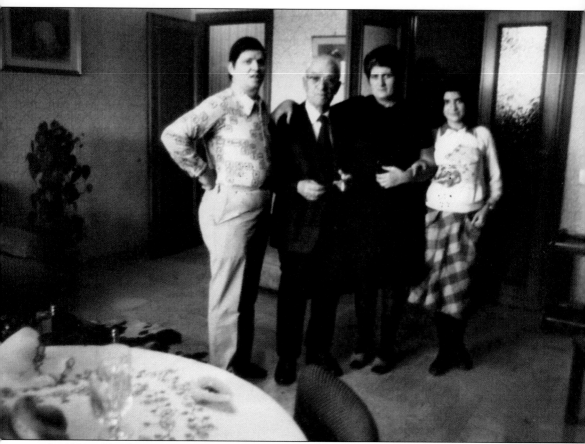

In 1908—like the Mongiardos, Policettis, and Cotispotis—Giuseppe (anglicized to Joe) Romeo (second from left) came through Ellis Island with no English language skills, with little or no money, and was labeled with his destination, Beckley, West Virginia. It is not known if immigrants had a piece of paper attached to their clothing stating their destination or if their clothes were written upon to this effect. Since they spoke no English, authorities checking in hundreds of immigrants a day must have found a quick method to process their entry to America. Romeo had not been formally trained or apprenticed as a stonemason in Italy. Thus, he and other workers like him honed their masonry skills while building the L&N bridges and tunnels. (Courtesy of Patty Majority.)

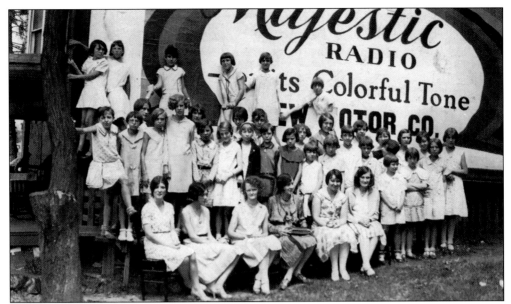

In 1928, Presbyterian Church Sunday school students and teachers pose before a Majestic radio sign. The New Motor Company sold elaborate radios in English-inspired cabinetry. The following appear, in no particular order: Viola Cook, Bernice Collins, Yarlett Swisher, Minerva Adams, and Nina Mullins. (Courtesy of Graham Memorial Presbyterian Church.)

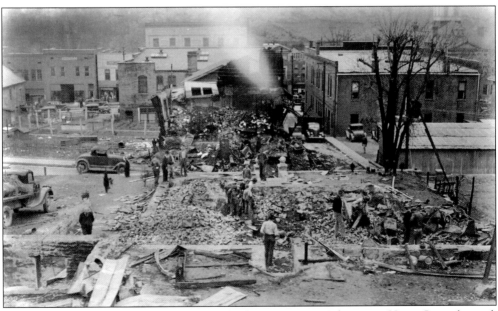

On Sunday morning, April 29, 1937, Dr. Charles G. Passmore's home on Hayes Street burned, igniting the Hayes building opposite it. A bucket brigade was formed while Jenkins and Cumberland firefighters came to the rescue. Both establishments were lost to the fire but many homes were saved. The Hayes building housed the Police Court, the J.L. Hayes law offices, and the *Letcher County Leader*, a Whitesburg newspaper. (Courtesy of Graham Memorial Church.)

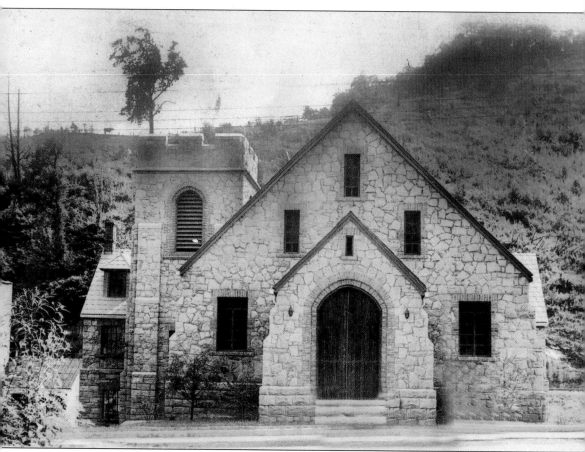

In 1931, work on a new Presbyterian church began on Broadway Street. Hop Gibson was the carpenter for the church, and Joe Romeo was chosen as general contractor. The Reverend O.V. Caudill, who had been with the church since 1927, sketched a design for the building and asked Miller and Gratz Inc., architects from Lexington, Kentucky, to draw up some plans. The congregation decided to go with the random pattern stone placement suggested by Joe Romeo and Frank Majority Sr. To achieve the random pattern, the masons used stones that were not dressed and pointed. They were smooth-edged stones, laid to fit like puzzle pieces. The masons brought with them this style, reminiscent of a stone-laying technique used to support stucco walls in their native Italy. Caudill and the congregation joined to raise funds for the building, but the Great Depression of the 1930s slowed construction. It was a visitor from Mason, Virginia, Mary Graham, who endowed the church with enough funds for completion. The church has since been called Graham Memorial Presbyterian Church. (Courtesy of Rachel Breeding.)

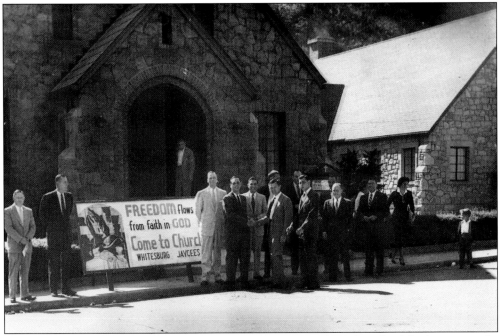

By the 1950s, Graham Memorial Presbyterian's congregation and Sunday schools had outgrown the original structure. The church decided to build an educational annex that would include more Sunday school rooms, a pastor's study, and a fellowship hall. Bill Conley gave a substantial contribution to the program, and the church voted to call the expansion the Conley Annex. The fellowship hall was named to honor D.W. Little for 10 years of service as Sunday school superintendent. (Above, courtesy of Leigh Lewis Blankenbeckler; below, courtesy of Deborah Cooper.)

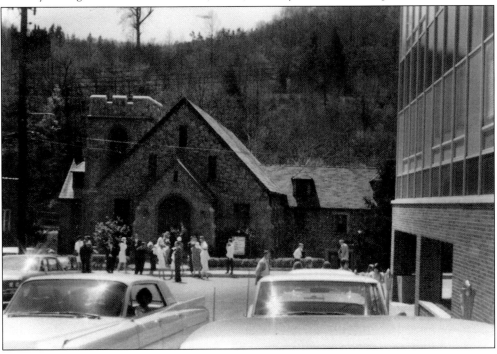

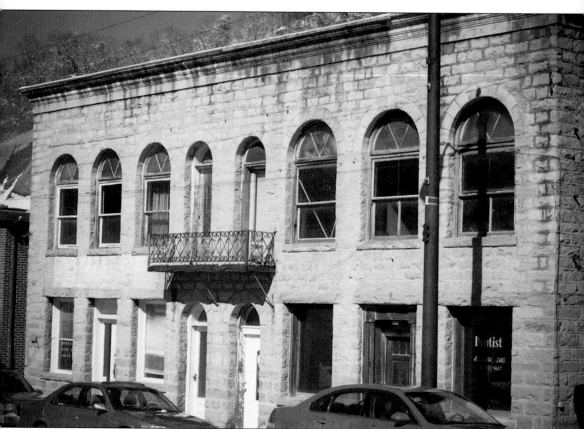

The W.E. Cook building was the first building in Whitesburg to be constructed entirely of stone. This was Italian foreman John Palumbo Sr.'s largest project at the time. A keystone over an arched doorway is dated 1914. According to Justine Richardson, who wrote about Whitesburg's Italian architecture in 1992, "Considering other instances of Palumbo's dating techniques, that (the 1914 keystone) probably marks the year in which that stone was laid rather than the date of the building's beginning or completion." The Cook family established a farm supply, grocery, dry goods, and general sundry store on the first floor and lived on the second floor. The W.E. Cook building has housed several businesses over the years, including the *Mountain Eagle* newspaper offices. (Photograph by Shonda Judy.)

An unidentified young woman sits in a window of the W.E. Cook grocery store. From the way she is dressed, her hairstyle, and her shoes, the picture appears to have been taken during the 1920s. A doll appears inside the store window at the right. (Courtesy of Susan Day Brown.)

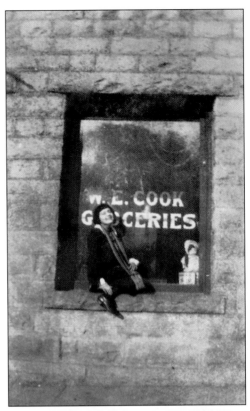

The foundation for the First Baptist Church was laid by the stonemasons, and the church was dedicated on April 25, 1915. The church was on East Main Street at College Drive, where Hoover's Home Furnishings is currently located. This church sanctuary was razed, and a new church was built on Madison Street and dedicated on June 21, 1964. (Courtesy of LCHS G. Bennett Adams Collection.)

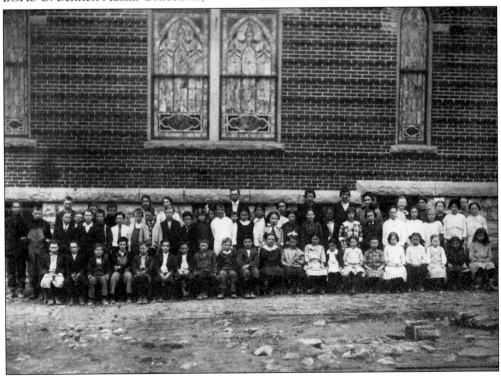

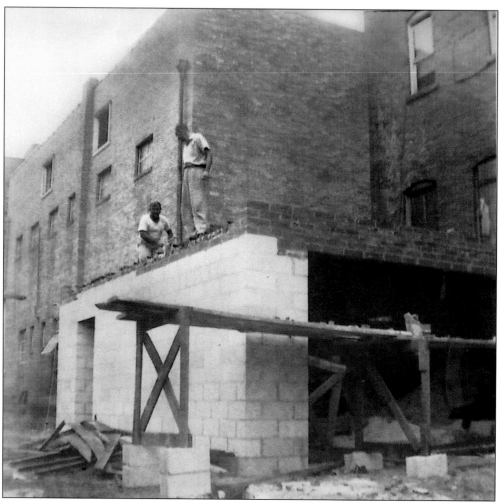

A great story about Frank Majority Sr. is captured by author and attorney Harry M. Caudill in his 1980 book, *The Mountain, the Miner, and the Lord*. Because Whitesburg did not have a Catholic church, several of the Italians attended Presbyterian services. In fact, Majority helped organize the men's Bible study class and was there almost every Sunday morning. He attended so regularly that the community thought he was Presbyterian. The story goes that when Majority became old and ill, he sought out a Catholic church in the coal town of Lynch. Majority and the Roman Catholic priest there became great friends, and it was to the priest that Majority made his confessions in his final days. Caudill, confused by Majority's change of heart after attending Presbyterian services his whole life, asked the old man about it. He replied, "Getting ready to die is too important to handle through the Presbyterians." (Courtesy of Patty Majority.)

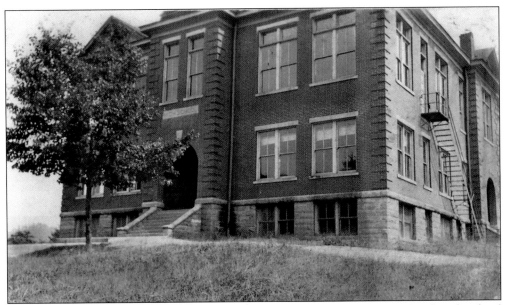

In 1918, the original Whitesburg High School opened its doors to high school and grade school students. In 1985, this sentimental old brick building was damaged by a tornado and subsequently dismantled. Bricks and stone were given to the students in memory of the time they had spent there. (Courtesy of LCHS.)

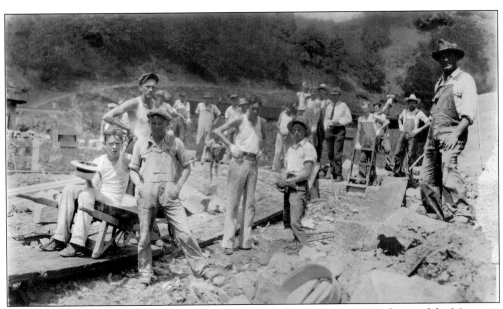

According to Augusto Cotispoti in an interview with Pat Gish in a 1965 edition of the *Mountain Eagle*, stone in Letcher County was here for the taking after the construction of the railroads in 1911 and 1912. The enterprising masons simply had to go out into the fields and pick it up where it had been dumped during the blasting and cutting that was necessary to get the Louisville & Nashville rails into the mountains. (Courtesy of Graham Memorial Presbyterian Church.)

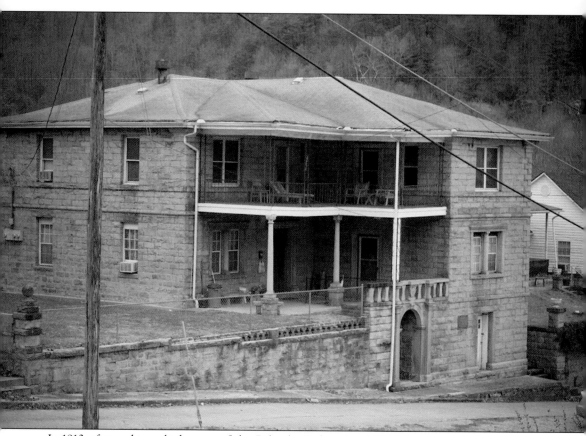

In 1913, after making a little money, John Palumbo Sr. bought a hillside lot next to Policetti's home overlooking Whitesburg and began "building a house that would last forever." His final design was a 10-room, tile-roofed masonry house with two chimneys and a kitchen flue to accommodate a "cook stove." Mae Cox, Palumbo's daughter who offered the above comments, also said, "It was like he was putting all his design knowledge in one house." This house (pictured above) was one of the first in the area with a bathroom and rudimentary indoor plumbing. Palumbo positioned his home adjacent to the street and flat against the Policetti house, which unfortunately no longer exists. In 1922, when Palumbo finished construction of his home, most mountain people had front porches on which to sit and greet passing neighbors. This position of the house, almost on the sidewalk and with no front yard, was a radical idea in eastern Kentucky. (Photograph by Shonda Judy.)

It was in 1919 that Alfonso Policetti cut the arched entryway for John Palumbo's house. Palumbo did all of the ornamental work on the house. The sandstone used for this home was quarried on River Road, behind the Salyer home in Whitesburg. (Photograph by Shonda Judy.)

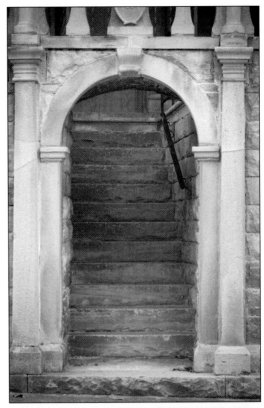

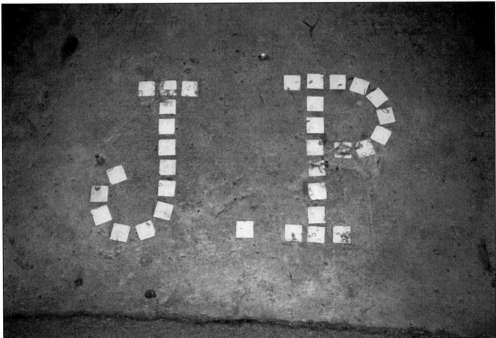

When John Palumbo Sr. finished his artistic masterpiece, his home, he placed the initials "J.P." in white tile at the front entrance. (Photograph by Shonda Judy.)

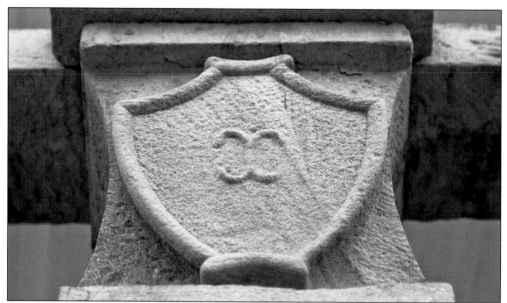

The crest pictured above is found at the top of the Palumbo house's entry arch. John Palumbo came from a peasant farming family, and they would not have had a crest. Palumbo told his daughter Mae Cox that the crest did not mean anything. Justine Richardson concludes, "He appropriated this traditional European symbol of power and importance to express his own dreams. By creating his own crest and placing it above the entrance to his home, Palumbo proclaimed his success in America by the standards of his Italian home." (Photograph by Shonda Judy.)

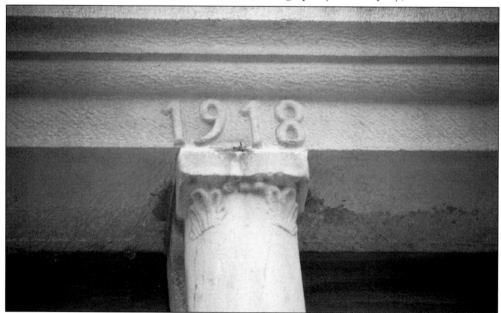

In 1918, Palumbo enlisted in the army to fight in World War I and fulfill his patriotic duty. He had only completed the masonry work on his home up to the second floor. Before leaving for Europe, he carved the year, 1918, in the lintel above the first set of double windows. This date marks a specific point in the house's construction. Palumbo returned from the war in 1920 to finish the building of his home. (Photograph by Shonda Judy.)

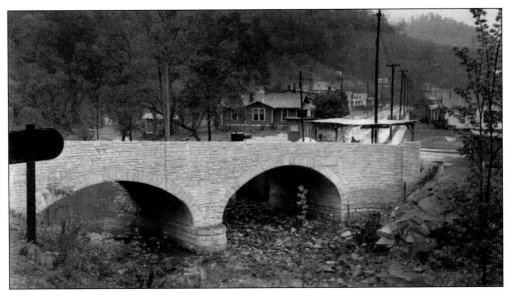

Work slowed for the stonemasons during the Depression of the 1930s. In 1936, however, Letcher County engineer R.R. Crawford designed the arched bridge (pictured above at its completion) that still spans the Kentucky River from Highway 15 to the Upper Bottom of Whitesburg. According to Justine Richardson, "The bridge was designed . . . specifically for the masonry skills of John Palumbo, Frank Majority, and Joe Romeo. . . . The masons treated each pillar differently . . . [to add an] attractive hand-crafted element beneath the boring, industrial concrete roadways." (Courtesy of University of Kentucky Archives.)

Typically, the stones for the bridge's construction were brought from the quarry on carts. They were dressed and squared near the riverbank. The masons had to find the center of balance for each stone, which they hoisted into place by a mule-driven derrick. The holes from the derrick are still visible in the bridge's stonework. These structures are reminiscent of the bridges that crossed streams in the masons' native Italy. (Photograph by Shonda Judy.)

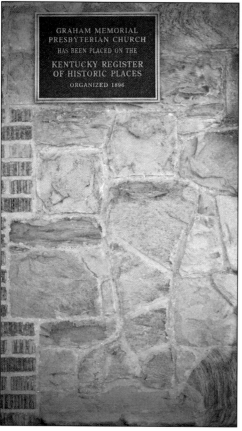

One has to smile upon discovering the legendary boot of Italy that the stonemasons placed on the portico of the Presbyterian church. Frank Majority Jr. recalls his father and Joe Romeo discussing this stone, which sent them into reminiscing over stories of their youth in Italy. World War II was looming when the masons finished work on the church, and Italy was beginning an alliance with Germany. According to Kiny Kincer, who was a deacon in the church, the congregation decided that this symbol was subversive and had to be removed. Fear arose, and the boot was chiseled in an attempt to render it unrecognizable. As shown above and at left, the Italian boot is still quite intact and a visual reminder of the artists' love for their country. (Both, photograph by Shonda Judy.)

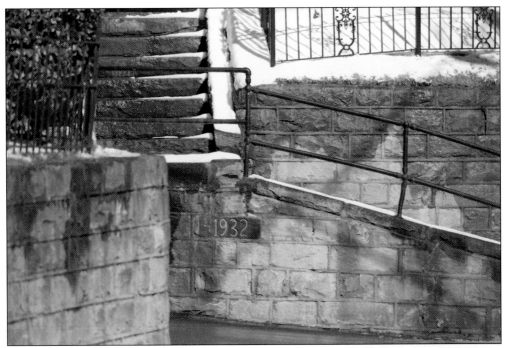

Masonry retaining walls and steps line the streets of Whitesburg and the foundations of many buildings. The Salyers' Bed and Breakfast, located on the corner of River and Hayes Streets, is just one example. The block engraved "1932" denoted the year the stone was placed rather than the beginning or end of construction. (Photograph by Shonda Judy.)

Shown at right is another design used by the masons for retaining walls throughout Whitesburg. (Photograph by Shonda Judy.)

This March 1913 view shows Jenkins from Pound Gap. In the center of the photograph is Consolidated Coal's massive brick and stone powerhouse. It provided electricity for several company towns. (Courtesy of Alice Lloyd College.)

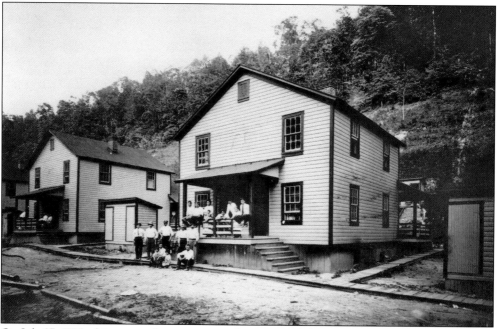

On July 27, 1913, this group of immigrant coal miners and their families were photographed on the porch of a company row house in Jenkins. (Courtesy of Alice Lloyd College.)

In 1939, under the leadership of attorney Stephen Combs Jr., French Hawk, A.J. Clay, S.M. Childers, and B.F. Salyers, and with the consensus of the congregation, it was decided that First Methodist Church of Whitesburg needed a new structure in which to worship God. The church already owned the lot at the corner of Main and River Streets where their wood-frame church had burned. They set about making plans, hired an architect, and began holding worship services in the basement of the Daniel Boone Hotel. The congregation was small, with small incomes, but all were encouraged to "bring the first fruits." With the presence of suitable stone (on River Road) and expert stonemasons in town, it was decided that the new church would be built entirely of local stone. In 1940, the contract for the masonry was awarded to Joe Romeo. (Both, photograph by Shonda Judy.)

In 1941, Ellis Morgan (who also ran the Pine Mountain Hotel) and Dewey Polly built the Coca-Cola plant next to the Kentucky River on Highway 15. Frank Greco did a major portion of the stonework for this building. Smooth, multi-colored stones taken from the shallow river bottom nearby were used in a random pattern design similar to the pattern used on the Presbyterian Church. In 1990, this building became home to the Southeast Campus of the Kentucky Community and Technical College. (Both, photograph by Shonda Judy.)

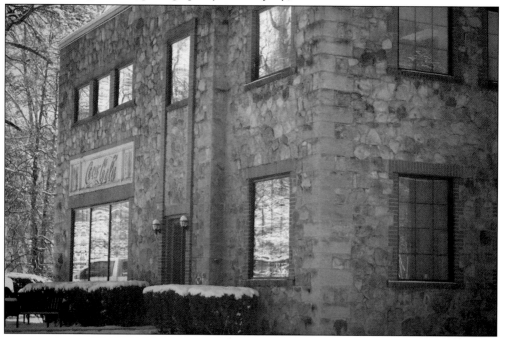

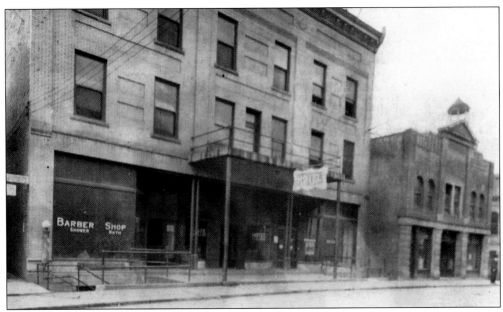

When Italian American Augusto Cotispoti returned to his Letcher County home from World War I in September 1919, construction had begun on a new hotel in Whitesburg, the Daniel Boone. Albert Williams, who was in charge of the construction, asked Cotispoti to add his skills to the task. Cotispoti, along with Policetti, cut all the stone windowsills and column bases and helped to lay the brick. Hop Gibson oversaw and helped do the carpentry work. The building was finished and dedicated at Christmastime in 1919. Larry Caudill, who was a *Mountain Eagle* reporter and Centre College student home for the holidays, recalls attending the grand opening party. In August 2010, the Appalachian Regional Commission awarded the city of Whitesburg a grant for its planned restoration of the hotel. The Daniel Boone was bought in 1958 by Mr. and Mrs. L.C. Banks from the estate of J. Speed Nicholson. Below, a 1925 photograph gives a rare peek inside the original and elegant dining room of the Daniel Boone. (Both, courtesy of LCHS.)

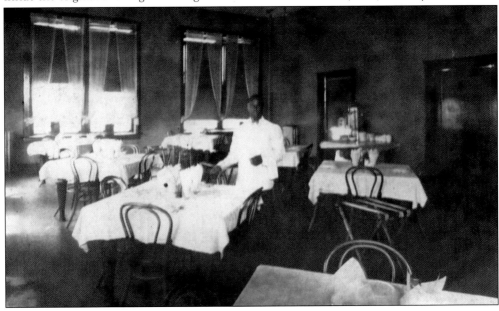

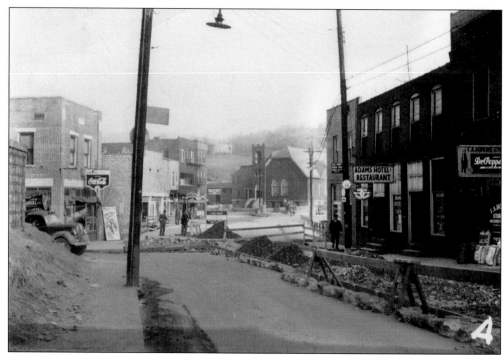

The stonemasons built the First Baptist Church in Whitesburg, which was dedicated on April 25, 1915, and is seen in the distance in this 1941 photograph. The front part of the church was torn down in 1965 to make room for the Hoover Building. At left with the Coca-Cola sign is the Tom John building, which was home to the Coney Island Restaurant. At right are the Sandy Adams Hotel and the F.A. Hopkins Grocery. (Courtesy of University of Kentucky Archives.)

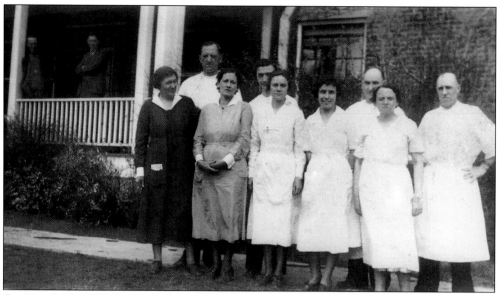

On March 20, 1935, doctors and nurses on the campus of Stuart Robinson School, located in Blackey, Kentucky, take a break from their "tonsil clinic." (Courtesy of Stuart Robinson School Collection, 1913–1957, Berea College Special Collections & Archives.)

Two

THE COUNTY SEAT

The warmth and energy of the pioneer spirit that settled this land still greets visitors and residents upon entering the small town of Whitesburg. Once called "Summit City" because of its location overlooking the North Fork of the Kentucky River, Whitesburg embraces and continues to celebrate its heritage. The past is present here in what are some of the finest works of Italianate architecture to be found anywhere in southeastern Kentucky. (Photograph by Shonda Judy.)

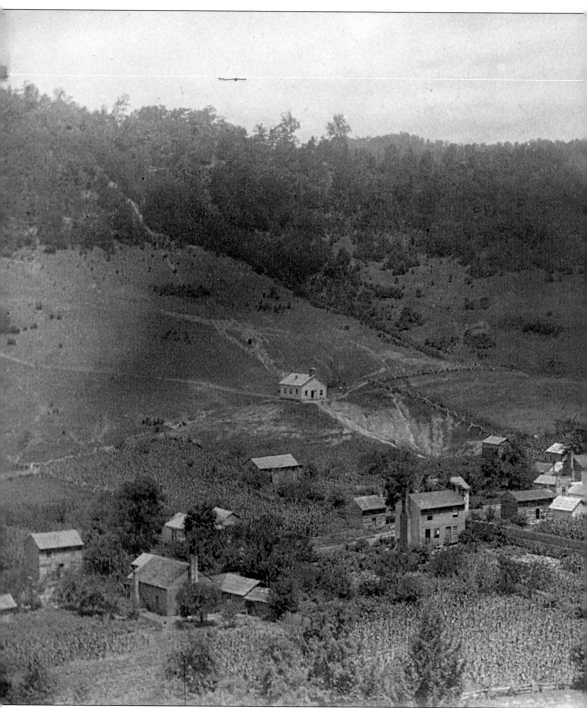

This 1890 photograph of Whitesburg, looking eastward, shows the old wooden courthouse (built in 1844) with a narrow pointed cupola (right of center). Just to the right of the courthouse is the jail, which was built sometime after July 1864. The jail has two distinct sections. The older log section is in the back with the newer clapboard section (closest to the courthouse) in the front. Across Main Street from the courthouse is the first brick house to be built in Letcher County. It

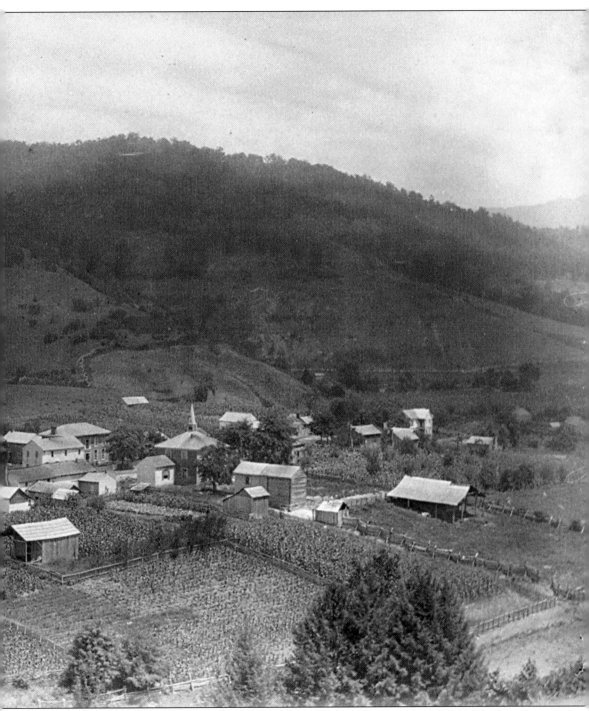

was the home of James H. Frazier. The white building to the left and on the hill is the Presbyterian Church. Letcher County was primarily agricultural at this time. The beauty of the Appalachian Mountains surrounding this fledgling town is reminiscent of a life lived more simply than today. (Courtesy of Filson Historical Society, Louisville, Kentucky.)

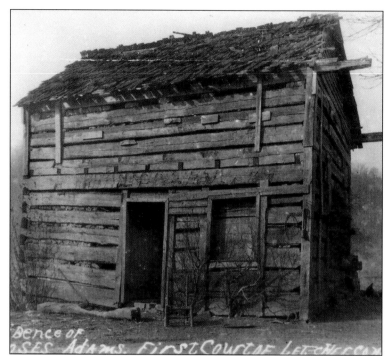

Letcher County residents first gathered for court sessions at the home of Moses Adams, located opposite the mouth of Pert Creek between Whitesburg and Mayking. Adams built this log home in 1812. Nathaniel Collins, who was born on the Camp Branch section of Rockhouse Creek in 1814, was chosen as Letcher County's first presiding judge. He served for 10 years. (Courtesy of Alice Lloyd College.)

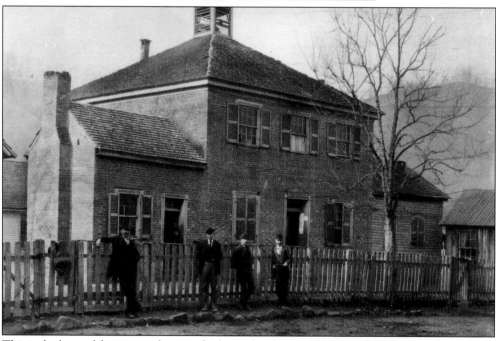

This is the log and frame courthouse, which was finished in 1844. Joseph E. Cornett (1814–1891) followed Nathaniel Collins as county judge. According to William T. Cornett's *History of Letcher County*, Joseph Cornett "helped in the 'laying out' " of Whitesburg during his term in office. In 1897, due to disrepair, the courthouse was torn down. The bricks for the newly planned courthouse were burnt immediately next to the site. County officials were able to move into the new brick courthouse by mid-1899. (Courtesy of Alice Lloyd College.)

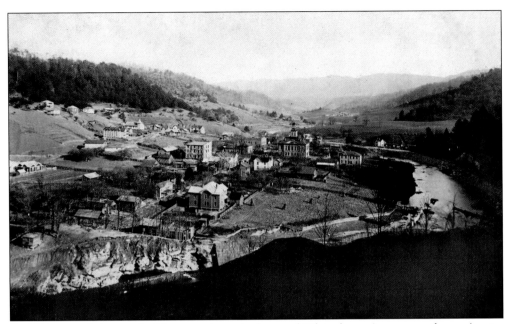

By 1911, several changes had been made to the heart of Whitesburg. A new courthouse (center right) featuring a belfry with a bell used to call people to court was built in 1899. The building to the right of the courthouse is the new stone jail, which was built around 1908. (Courtesy of Sheila Swisher.)

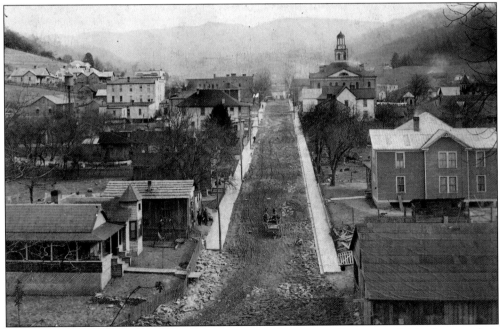

A better view of the 1899 courthouse can be seen in the upper right corner of this photograph. It was taken from what is now known as Fields Cliff Drive, looking to the southeast. The streets here are unpaved, and wooden sidewalks line Main Street. The courthouse was heated with fireplaces and stoves until 1937. An addition to the original building was constructed in 1936–1937 by the Works Progress Administration. (Courtesy of LCHS.)

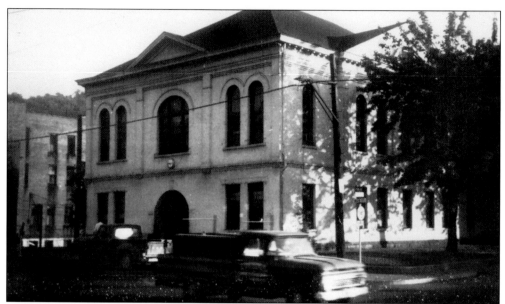

By the early 1960s, Letcher County had outgrown the 1899 courthouse (above with the cupola long gone). Federal funds were used to raze this courthouse and provide for a new one. William Moore, a Louisville architect, designed a contemporary-style building (pictured below) with a blue-and-beige-paneled facade. The new structure allowed for a jail on the top floor and a public library on the ground floor. The building was dedicated with a speech from Kentucky governor Bert T. Combs on April 3, 1965. (Courtesy of Alice Lloyd College.)

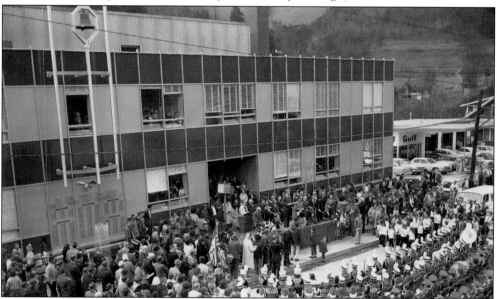

The Gulf filling station owned by Otis Mohn is pictured on the right. That space is now a parking lot for Letcher Funeral Home, located next door. The Whitesburg High School band is sitting in the first few rows. Letcher County judge James M. Caudill is speaking at the podium. The modern design of the building drew mixed reviews, and by the 1990s, state officials were threatening to close the third-floor jail. County officials secured federal funding to renovate the building, and the newly remodeled courthouse (not pictured) opened in 1998. (Courtesy of David M. Fields.)

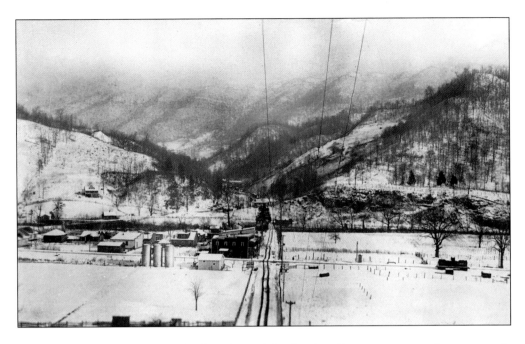

Above is an undated photograph of Mayking. After Letcher County was created, many people thought the area where Mayking now stands should be the site for the courthouse and, thus, the county seat. It seemed the obvious choice because Mayking was the earliest and most densely populated settlement. Hiram Hogg, however, offered to donate a portion of his land (where Whitesburg now stands) for the new courthouse, on the condition that the county seat be built there. Whitesburg (pictured below) was the only actual town in Letcher County until the advent of the railroads in 1911–1912 and the building of the coal camps. (Above, courtesy of LCHS; below, courtesy of David M. Fields.)

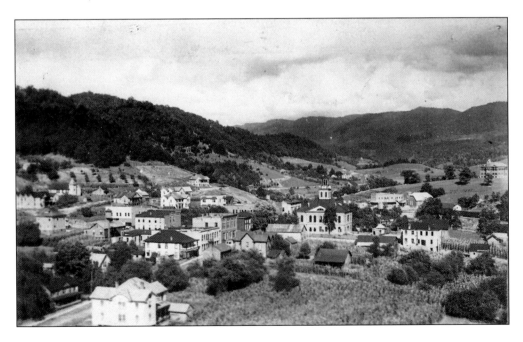

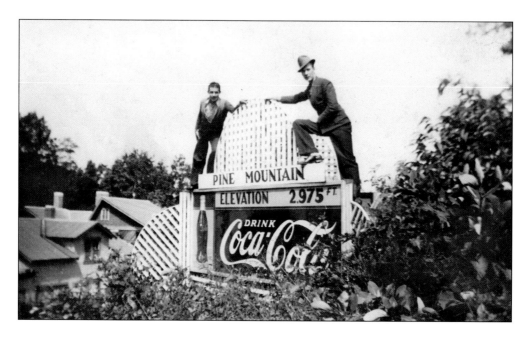

Pine Mountain is a 125-mile-long ridge in southeastern Kentucky that traverses Bell, Harlan, and Letcher Counties and reaches its highest point just east of Whitesburg. Five miles of road wind up through wooded slopes, which tower gracefully above exhilarating valley views on Kentucky's second highest mountain. It rises to an altitude of 3,273 feet above sea level. In the late 1940s, George Dewey Polly, following the lead of Vincent Sergent, began development of a Pine Mountain Resort. Polly took advantage of the three existing lakes atop the mountain by offering swimming, diving, and boating. He also created Eagle View Lake, spanning an acre and a half, to be used in winter for ice skating and hockey. Below is a photograph of two unidentified men at the Skyline Tavern. (Both, courtesy of LCHS.)

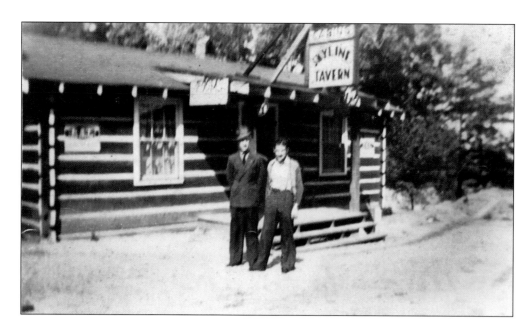

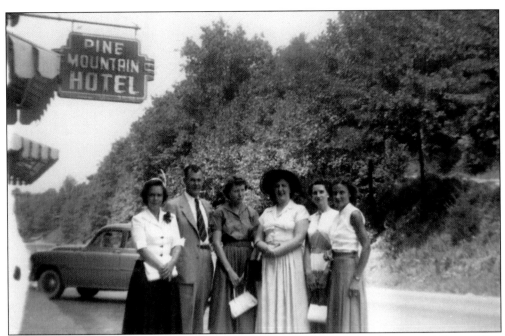

The Pine Mountain Hotel dining room was a popular after-church luncheon spot. Ellis and Bea Morgan owned the hotel at its heyday in the 1950s. Bea is still remembered for her homemade pies. Photographed above are, from left to right, Betty Little, James Breeding, Bonnie Combs Craft, Patsy Fields Bowen, Jeanette Wampler, and Glendora Fields Ison. (Courtesy of Rachel Breeding.)

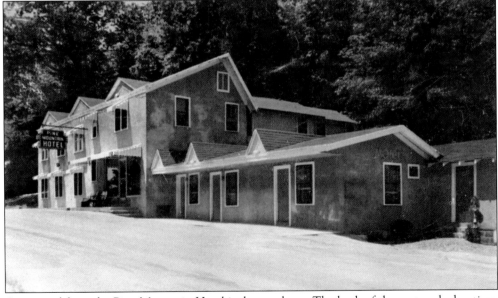

A postcard from the Pine Mountain Hotel is shown above. The back of the postcard advertises, "Located on US Highway 119, 5 miles South of Whitesburg and 15 miles north of Cumberland, Ky. 3,000 Ft. elevation, cool, scenic spot of Ky. Mountains. Scenic Tower, lake, trails, picnicking, and swimming. Twenty-one modern Hotel and Motel Units, tile bath, steam heat, Excellent Grade A Dining Room. Pine Room for banquets, entertainment. Phone No. 2572." (Courtesy of Deborah Adams Cooper.)

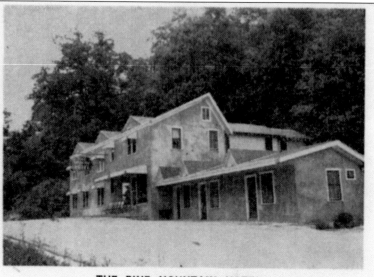

Located a-top Scenic Pine Mountain stands this beautiful Motel, operated by Mr. and Mrs. Ellis Morgan and little daughter, Karen. The elevation is 2600 feet and provides an ideal lodging place for tourists traveling either North or South over US Highway 119. Excellent food and modern conveniences attract thousands of tourists each year. A Kentucky game preserve is located nearby and provides wildlife of several varieties.

THE PINE MOUNTAIN MOTEL
Whitesburg, Kentucky
An Excellent Lodging Place for Tourists

A Pine Mountain Motel picture card advertises a Kentucky game preserve located nearby that provides several varieties of wildlife. The card states that the motel is operated by Mr. and Mrs. Ellis Morgan and "little daughter Karen." W.P. Nolan, who purchased and edited the *Mountain Eagle* in the 1930s, has a poem on the back of the card entitled, "Welcome Traveler." (Courtesy of Mrs. Ellis Morgan.)

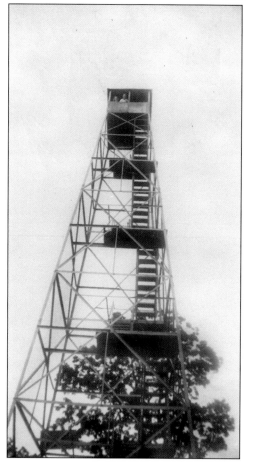

The ranger lookout tower on top of Pine Mountain was a popular tourist attraction. It was a 15-minute walk from the Pine Mountain Motel and the best spot to gaze upon the amazing beauty of the hill country. A close look at the image reveals two young men at the top enjoying the view. (Courtesy of LCHS.)

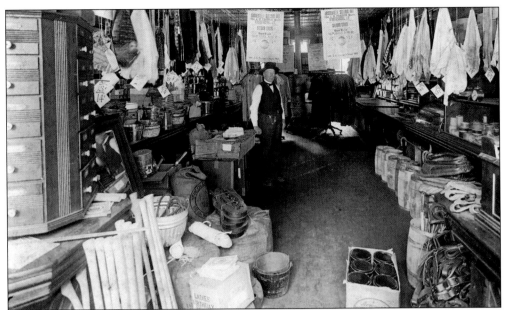

James H. Frazier is pictured in his general store sometime during the 1930s. The building Frazier constructed still stands on the corner of Main and Library Streets next to the old Daniel Boone hotel. The story of Jim Frazier's father is that he was a landowner who had grown wealthy from selling timber off his land. Young Frazier told his father he wanted to leave the timber farm and go into business for himself. Frazier's father told him he could have a large poplar tree on the farm and what it would bring if he could haul it to the steam mill in Letcher County. The young Frazier, who was about 15 at the time, did just that. He sold the log for seven dollars and began a little general store in a room in his father's house. In 1914, young Frazier bought land and built the general store shown above. Today, it is known as the J.H. Frazier building (pictured below). (Above, courtesy of David M. Fields; below, photograph by Shonda Judy.)

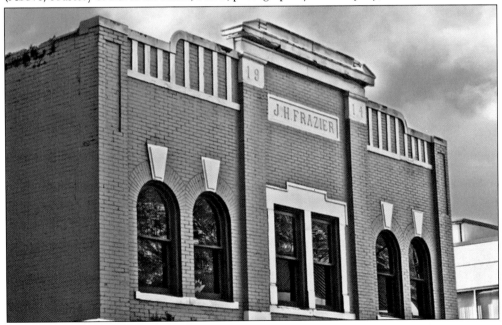

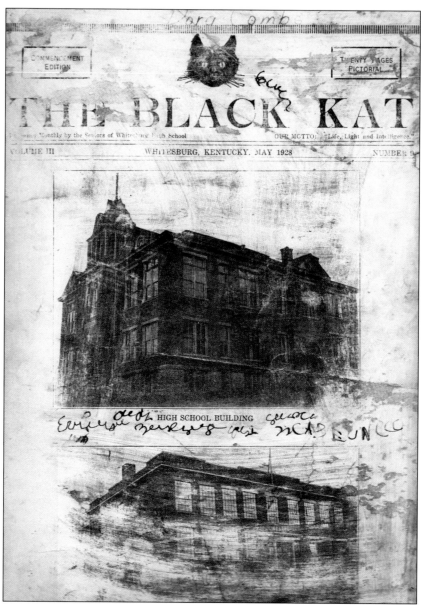

Whitesburg High School published this commencement edition of the *Black Kat* on May 28, 1928. Members of the 1928 senior class included Hazel Back, Zenneth Bentley, Barzella Bates, Kermit Boatright, Jennie Caudill, Dora Combs, Lora Combs, Karl Day, Beulah Fields, Orell Fields, Eunice Lewis, Euretta Hammonds, May Logan, Ruth Logan, Norvell Lykins, Vera Sergent, Mildred Speaks, Mallie Strong, James Taylor, Taft Spradlin, George Taylor, Pansey Webb, and Hobart Combs. In 1928, R. Dean Squires was principal, there was an established board of education, and the county superintendent was Arlie Boggs. The *Black Kat* noted, "With the completion of the road to Seco and with a hard-surfaced road to the Knott County line, the Whitesburg and Letcher County High School is to grow in number until it will soon be necessary to build an addition to the high school building. This special edition of the *Black Kat* is urging boys and girls from the rural schools to become members of the best high school in Kentucky as soon as they have finished the eighth grade." (Courtesy of Susan Day Brown.)

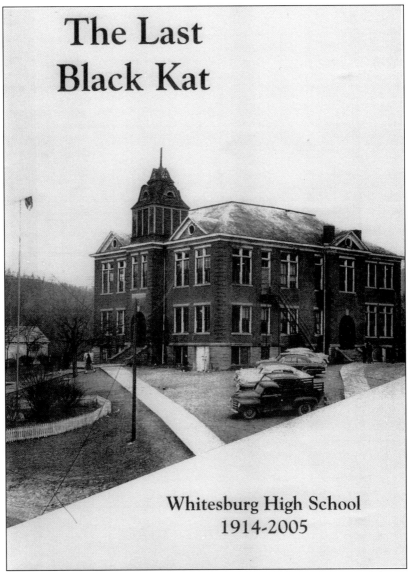

The Last Black Kat

Whitesburg High School
1914-2005

The Last Black Kat was published on July 30, 2005, with an accompanying celebration at the Campbell House–Crowne Plaza in Lexington, Kentucky. Editors for the *Last Hurrah* included Phyllis Hall Adams, Eva Lou Everidge Davis, Eloise Reynolds Delzer, Arlayne Collins Francis, Bert Francis, Arbadella Pigman Franklin, Windus Franklin, Ann Daniel Hall, Don Hughes, Walleen Enlow Morris, Joani Baker Powers, Janet Ison Tate, and Don Woodford Webb. The board of trustees of Whitesburg Graded School and the Letcher County High School hired Jerome Eastham as the first principal on July 28, 1914. The school's curriculum, which was approved by the state Board of Education, included rhetoric and composition, algebra, ancient history, medieval and modern history, botany, Latin, German, pedagogy, and English. Until the school was ready for occupancy, high school classes were held in the basement of the First Baptist Church at the foot of the school hill. Until 1980, the principals were Prof. Paul Hounchell (1917–918), Henry Howell Harris (1919–1927), Prof. R. Dean Squires (1927–1940), Orell Fields (1940–1942), Curtis Reed (1942–1946), Millard Tolliver (1946–1953), and Kendall Boggs (1953–1957). Jack Burkich served longer than any principal before him, from 1957–1979. (Courtesy of Phyllis Ann Hall Adams.)

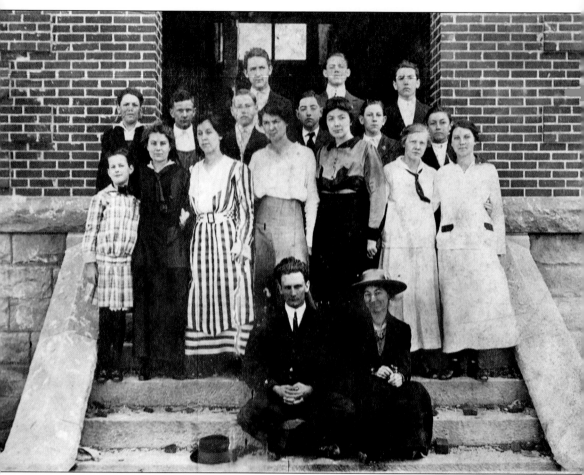

The faculty and students of Whitesburg High School in 1914 include, from left to right, (first row) teachers Jerome Eastman (who served as principal from 1914–1917) and Nancy Jane Huff (who served as principal's assistant); (second row) Grace Newman, Ora Day, Ida Mullins, Allie Fields, Polly Fields Eastman, Alpha Frazier, and Edna Fugate; (third row) Astor Hays, Curtis Lewis, Harrison Gibson, Beckham Caudill, Charles Fugate, and Herman Hale; (fourth row) Howard Fields, Henry Williams, and J.L. Hays. The first class to graduate Whitesburg High School was in 1916. This class graduated three young men: J.L. Hays, who became a lawyer and judge of the Letcher Circuit Court; G. Bennett Adams, who became an Old Regular Baptist preacher, county judge, and historian; and J.M. Bentley, who practiced dentistry in Whitesburg and Neon. (Courtesy of David M. Fields.)

Whitesburg Grade School's 1929–1930 fourth-grade class is shown with teacher Arlie Boggs (standing). Included in this group are, in no particular order, Grace Combs, Paul A. Cuff, James Bentley, Gertrude Brown, Ogden Blair, ? Back, Ruby Pendleton, Paul Tolliver, Susan Blair, Nellie Bennett, Edith Williams, Shade Adams, Marcus Patton, Helen Craft, Jim Majority, Lilly ?, Marie Williams, and Samantha Sloane. (Courtesy of Sam Collins Jr.)

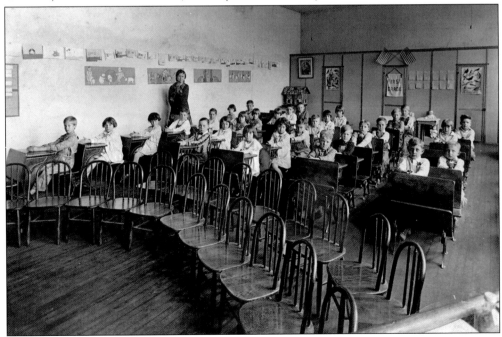

This 1928 photograph shows Whitesburg Grade School's first grade. Teacher Miss Felix is standing left of center. (Courtesy of Anne Caudill.)

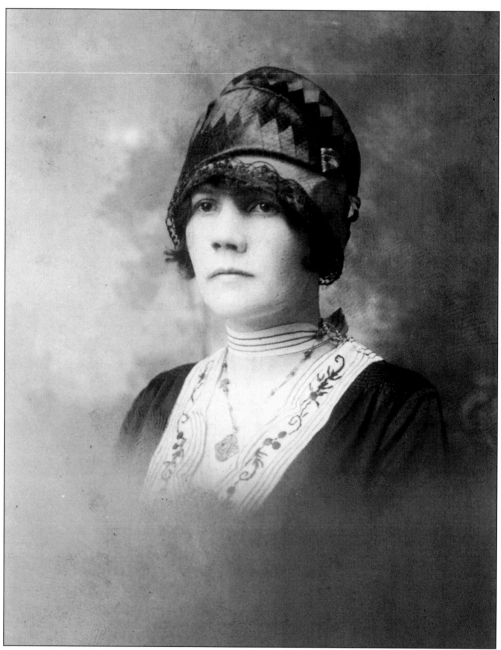

Rosa Parks Blair was from Carr Creek, which is about 10 miles south of Hindman, Kentucky, in Knott County. She worked as a telephone switchboard operator when this photograph was taken in 1921. Women began to enter the workforce after World War I. Blair is wearing a cloche hat, which was popular at the time. The word *cloche* is French for "bell." It is said that different adornments to the hat could send a message. For example, a ribbon tightly knotted might indicate that the wearer is married, and a flamboyant bow could signal that the wearer was single and looking for a suitor. The looser style of women's garments in the 1920s reflected the women's rights movement. In 1920, the US Congress ratified the 19th amendment, which prohibited state and federal agencies from gender-based restrictions on voting. (Courtesy of Geraldine Polly Blair.)

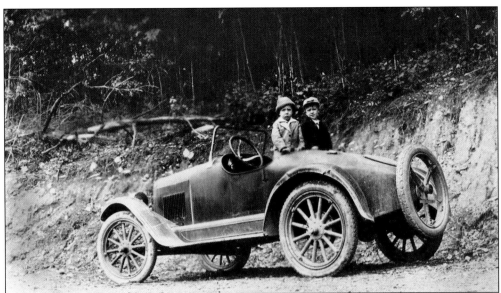

The above photograph was taken on Pine Mountain in about 1926. Jack W. Blair (left) and John "Jack" Passmore (right) are in one of father Charles G. Passmore's racing cars. The celebratory wedding photograph (right) was taken when the two couples honeymooned in Cincinnati, Ohio. Sitting are Rosa Parks Blair (left) and Ruth Collins Day. Standing are Emmett Blair (left) and Ercell Day. (Both, courtesy of Geraldine Polly Blair.)

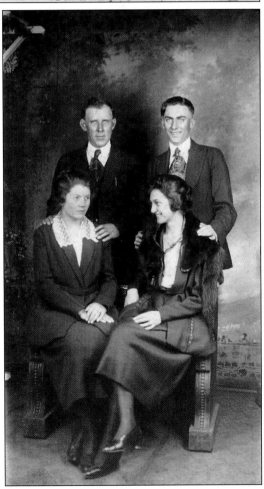

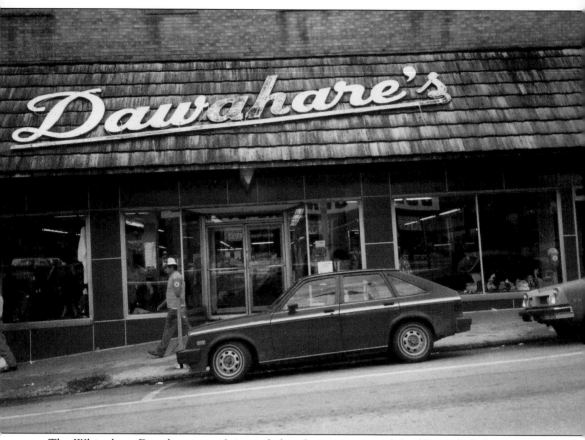

The Whitesburg Dawahare store (pictured above) was just one of the 25 retail clothing stores begun by the legendary Serur Frank Dawahare. Dawahare, to escape religious persecution in Damascus, Syria, came to the United States on August 18, 1888. After working for a time in a sweat shop in New York City, Dawahare decided he would try peddling merchandise in the new coal town of East Jenkins, Kentucky. Here, he opened a little temporary store and began to sell to other pack peddlers. In 1922, the growing family moved to Neon, Kentucky, and opened a larger store. Dawahare and his wife, Selma, had eight sons and three daughters. They moved to Whitesburg and opened their second store in 1935. The Serur Dawahare family was living the quintessential American dream. The family was so patriotic that they named three of their sons after United States presidents: Woodrow Wilson Dawahare, Warren G. Harding Dawahare, and Herbert Hoover Dawahare. Serur Dawahare's vision was for each of his eight sons to have their own store. His vision was met and surpassed. (Courtesy of LCHS.)

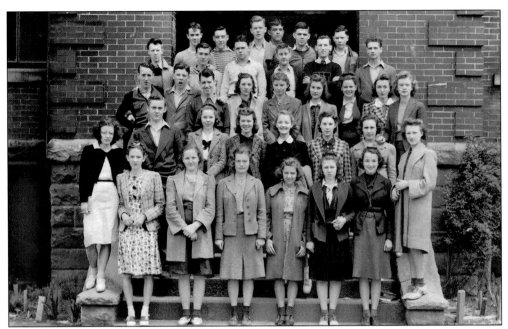

The Whitesburg High School Dramatic Club was organized in 1940 by Cleo Stamper and Don Brown. The *Mountain Eagle* reported that "members of the club give short skits and readings and have a series of plays planned for the fall." The club included Gene Moore, Stamper Collins, Louell Williams, Kermit Lucas, Eleanor Fairchild, and Peggy Williams. (Courtesy of Pat Yinger.)

The 1954–1955 Whitesburg Yellowjackets included Glenn R. "Buddy" Fields, who reportedly was "one of the most popular football players to wear the orange and black. . . . He received 16 varsity letters, which is a record for Whitesburg High School, lettering all four years in football, basketball, baseball, and track." He signed with Tennessee but transferred later to Morehead State, where he held the record for collegiate touchdowns (eight) by a Whitesburg graduate. (Courtesy of Pat Yinger.)

Children who were around Whitesburg during the 1950s and 1960s are sure to remember R.H. Hobbs five-and-dime store on Main Street. The bins above are loaded with colorful candies for 10¢ a pound. Pictured above in 1940 are, from left to right, Louise Williams, unidentified, Yarlett Swisher, Eula Mae Gibson, and Inez Fields. The Hobbs chain of stores in southeastern Kentucky began in Paintsville. Jack Cox moved his family to Whitesburg in 1940 and managed the store for

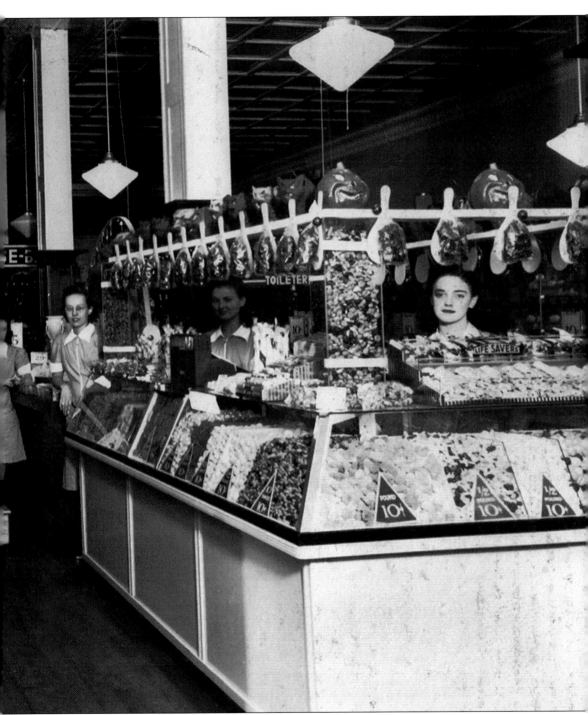

47 years. R.H. Hobbs' store was originally located in the George M. Hogg building (constructed in 1925), which burned in the early morning of March 7, 1949. The R.H. Hobbs building that replaced it burned in the early morning of August 27, 1971, after a lightning strike. In 1986, the Hobbs store was sold to the Letcher County Public Library and is now the location for the Harry M. Caudill Memorial Library. (Courtesy of Sheila Swisher.)

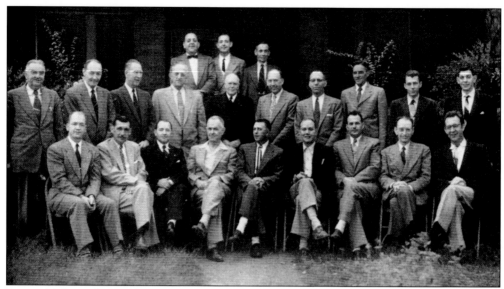

Rotary Club members include, from left to right (first row) Pat Napier, Archie Craft, Coy Holstein, W.L. Cooper, Otis Mohn, Jack Burkich, Newt Colyer, Louie Ammerman, and Clell Rogers; (second row) Stephen Combs, Herman Hale, Virgil Picklesimer, B.C. Bach, Pearl Nolan, Dave Craft, Lee Moore, Myrel Brown, Bob Fike, and Woodrow Dawahare; (third row) Kermit Combs, Hugh Adams, and General Croucher. (Courtesy of Susan Day Brown.)

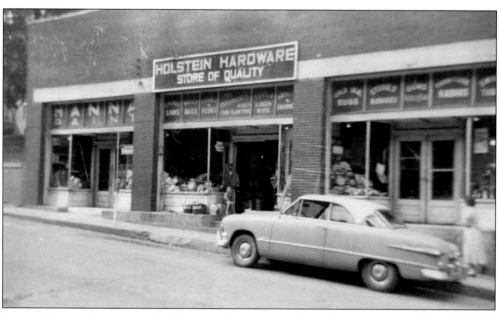

Coy and Rosa Holstein opened Holstein Hardware in 1941. The *Mountain Eagle* reported, "At one time the [Holstein] store was the largest dealer of Smith and Wesson firearms in the southeastern United States, a feat made even better by the fact that she and her husband never once ran afoul of the Federal Bureau for Alcohol, Tobacco, and Firearms. An ATF agent once told her husband, 'Mr. Holstein, you've got the best set of records of anyone we've ever checked.' " The store was open for 61 years and closed in 2002. (Courtesy of LCHS.)

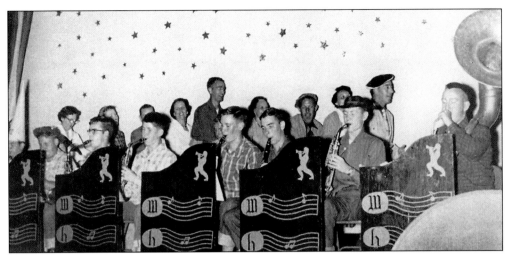

Whitesburg High School (WHS) held a PTA Variety Show on the night of the 1954 Halloween Carnival. Playing "The Bunny Hop," some of Jack Taylor's Orchestra members are, from left to right, (seated) Jack Taylor, Gail Potter, Bert Francis, John Lynn Rice, Johnny Doyle, Eddie Cornett, Don Hughes, and R.T. Holbrook; (line of "Bunny Hoppers") Nazaretta Price, Lucy Fields, unidentified, Dot Webb, Follace Fields, Clova Setzer, Ralph "Snake" Frazier, Peggy Hidvegi, and Ed Moore. (Courtesy of Bennett Welch.)

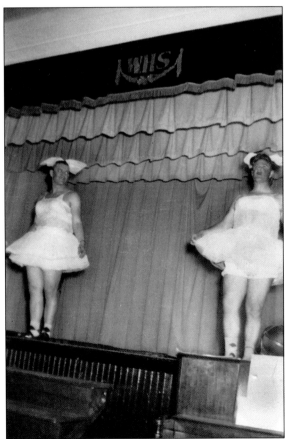

Cecil Caudill and Jim Boyd perform in a variety show directed by WHS band director Hugh Adams. According to Patsy Fields Bowen, Hugh Adams was a "cut-up" and a great man to be around. Patsy says that Adams would hold these shows to fund school achievement tests. (Courtesy of LCHS.)

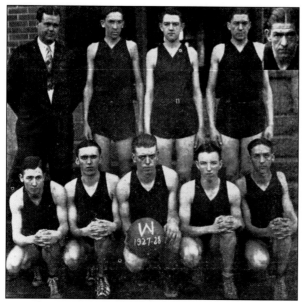

The 1927–1928 WHS basketball team, from left to right are (first row) Olan Cook, Lester Day, Hillard Hall, Woodrow Whitaker, and Henry Wright; (second row) Coach Marvin Glenn, Blair Adkins, Kelly Ewen, and Lincoln Combs. Cecil Baker (inset, top right) was not in attendance for the photograph. These young men were the first to train and play in the wood-framed building (below) that was built in 1927. The gym was 98 feet wide and had a playing space of 78 by 40 feet. It was known to have been well lighted with one of the best floors of any high school gym in the state. This gymnasium burned sometime around 1939. (Courtesy of Pat Yinger.)

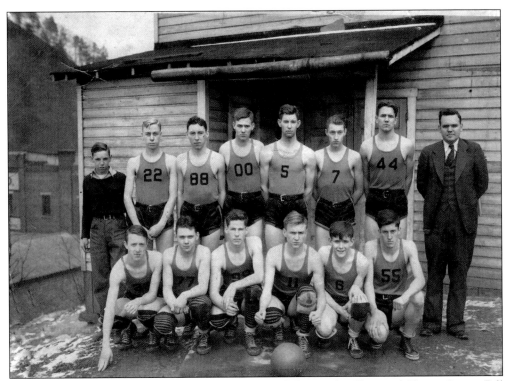

The 1938 WHS basketball team members are, from left to right, (first row) Kermit Lucas, Bill Tolliver, Walker Pigman, Herman Bates, Floyd Mercer, and Warren Reynolds; (second row) manager Durward Banks, Estill Blair, Edison Holbrook, Amos Cook, Craney Brush, Clay Stallard, Ted Cook, and coach Millard Tolliver. Under the direction of Coach Tolliver, WHS basketball teams made it to several state tournaments in the 1930s. (Courtesy of Pat Yinger.)

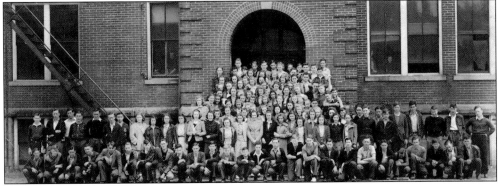

Whitesburg High School's 1939–1940 freshman class poses for a photograph. (Courtesy of Pat Yinger.)

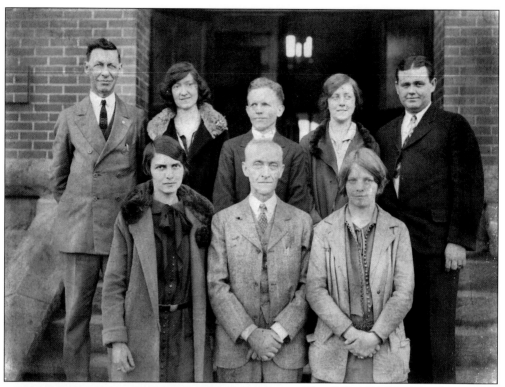

The 1927–1928 WHS faculty are, from left to right, (first row) Adaline Colyer, superintendent (principal) Richard Dean Squires, and Hazel Lewis; (second row) E.B. Hale, Cecile Elliott, William Harris, Elis Cleary, and Marvin Glenn. (Courtesy of Pat Yinger.)

Richard Dean Squires served as superintendent of Whitesburg's graded and high schools from 1927 to 1940. He was born in Bourbon County, Kentucky, and graduated from Centre College in Danville, Kentucky. (Courtesy of LCHS.)

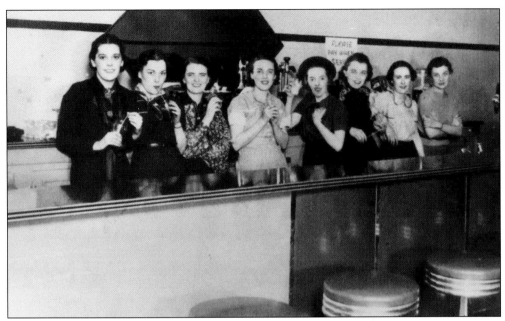

The Sweet Shop was the place to be in the late 1930s and early 1940s. It attracted high school students wanting a Cherry Coke and a grilled ham sandwich. There was a nickelodeon in the rear where students were allowed to dance. Sweet Shop regulars are, from left to right, Willa Maggard, Maude Day, owner Nan Lou Salling Lucas, Faye Collins Minton, Bernice Collins, Jesse Triplett Lewis, June Salling Webb, and Virginia Vermillion. (Courtesy of Leigh Lewis Blankenbeckler.)

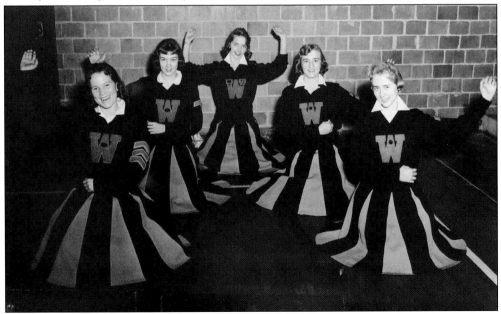

The Orange and Black are cheered on in 1957 by, from left to right, Linda Phillips, Mary Rodgers, Margaret Bach, Judith Combs, and Beth Lucas. In the late 1950s, 25¢ could buy you a movie at the Alene Theatre or admission to a sock hop. The *Mountain Eagle* reported in 1957 that after a pep rally at the Rainbow Grill, "the band, cheerleaders, and fans will parade through town, doing the snake dance and yelling, after which there will be a bonfire on the hill." (Courtesy of Pat Yinger.)

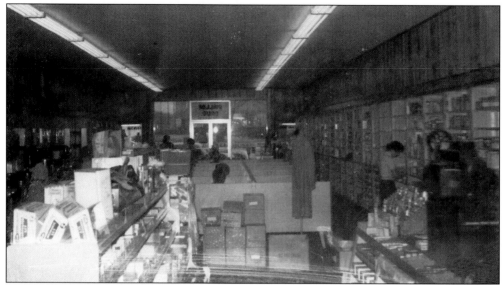

In December 1956, Cossie Quillen opened a new Quillen Drugstore with a soda fountain, which quickly became a favorite after-school hangout. The pine paneling that was popular in the 1950s is visible in the photograph above. Hobo's Diner serves lunch there these days. Notice the row of booths down the center. Fred Coffey, a Wayne County native, managed the store. Pictured below is the exterior of the new drug store located in the building that once housed the Kentucky Theatre. The sign in the market window next door is advertising "friers" for 35¢ a pound, steak and ham at 59¢ a pound, and three dozen eggs for a dollar. (Both, courtesy of LCHS.)

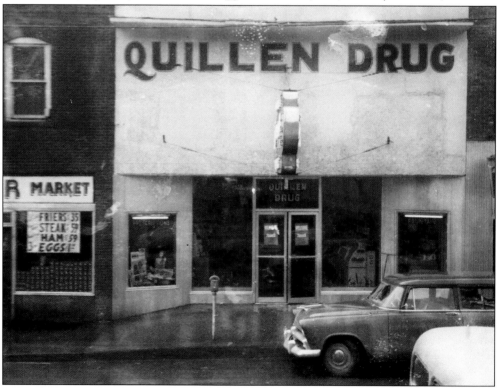

Flowers are presented to Rosa Jones by two young girls who have just performed a recital. Jones was a beloved Whitesburg High School teacher who taught public speaking and music. Many a child learned to play the piano through private lessons with her. (Courtesy of Phyllis Hall Adams.)

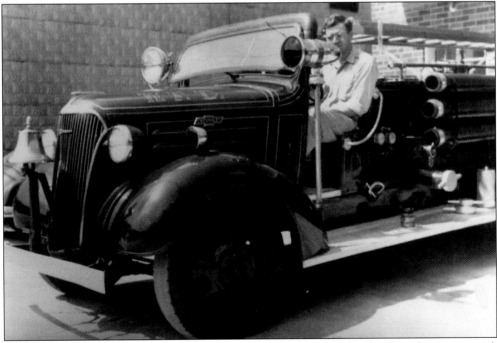

Sam Collins Jr. was assistant fire chief at one time. In 1970, Collins served on the city council. Collins was also an atomic energy worker, mine and tipple operator, postmaster, and building contractor. His businesses included Letcher Coal Sales, Collins and Crawford, and Highland Construction. (Courtesy of Susan Day Brown.)

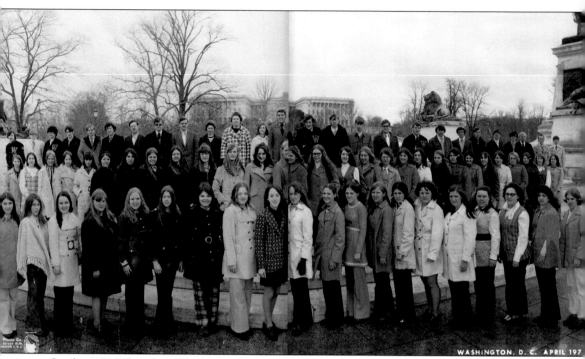

On the 1972 Whitesburg High School senior class trip to Washington, DC, are, from left to right, (first row) Glenda Miles, Vicki Prichard, Ada Fields, Linda Jackson, Dianna Ott, Mary Poloskey, Stella Buttrey, Mary Frazier, Teresa Baker, Shelia Everidge, Debby Thomas, Shirley Cable, Nina Sturgill, Freda Brown, Henrietta Wagner, Gwenda Watts, Gayle Riddle, Sarah Devlin, Paula Crase, Sherry Parrott, Mary Maggard, JoAnn Bowling, and Joan Ramsey; (second row) Carolyn Gibson, Barbara Ison, Juanita Watts, Geraldine Banks, Verna Bailey, Donna Collins, Linda Collins, Donna Childers, Charlene Williams, Sarah Gish, Caron Crawford, Maggi Fields, Maguana Blair, Ricky Adams, Mark Everidge, Ray Fields, Terri Cook, Lee Anna Collins, Linda Addington, Debby Bates, Linda Pigman, Vera Engle, Carolyn Parsons, Frenda Anderson, Janet Frazier, Darlene Hammonds, Kim Adams, Fay Gibson, Brenda Fields, Connie Frazier, Marilyn Wilson, and Debby Pratt; (third row) Carl Breeding, Gary Bowling, Tony Baker, Ricky Collins, Jimmy Craiger, Earl Banks, Gary Combs, Johnny Mounts, Wendell Cook, Jeanette Wampler, Mrs. Joy Wray Breeding, Mrs. Lyle Eads, Lyle Eads, Dan Polly, Carl Banks, Marsha Banks, Jack Burkich, Ruby Burkich, Gary Mullins, Bobby Anderson, Steve Collins, Randy Breeding, Danny York, Wade Brown, Charles Hatton, Keith Mohn, Monroe Hensley, John Palumbo, Stanley Collins, Woody Holbrook, and Gordon Caudill. (Courtesy of Lee Anna Mullins.)

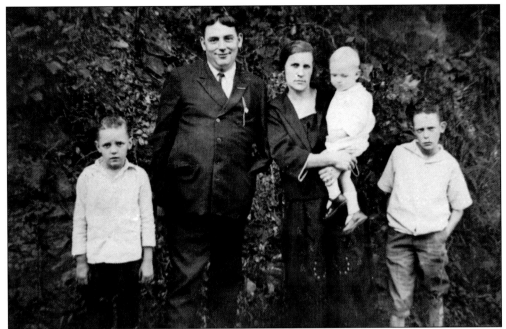

The Caudill (originally Cordill or Caudle) family came from Virginia in the mid-1790s and settled in present-day Blackey. Pictured above are, from left to right, James (who died at age 14), Cro (son of Henry R. Stephen Caudill), Martha Blair Caudill (holding a young Harry Caudill), and Truman Caudill. (Courtesy of Anne Caudill.)

Harry M. Caudill (1922–1990) was a Letcher County attorney and author who turned the nation's spotlight on Appalachia with the publication of his book *Night Comes to the Cumberlands: A Biography of a Depressed Area* in 1963. Caudill essentially highlighted what he saw as abuse by the coal corporations and the poverty he saw as a result. The book is credited with igniting the 1964 creation of the Appalachian Regional Commission, a federal agency designed to assist Kentucky and 12 other Appalachian states. *Night* and other publications in the late 1950s and early 1960s influenced President Lyndon B. Johnson to call for a War on Poverty. (Courtesy of Anne Caudill.)

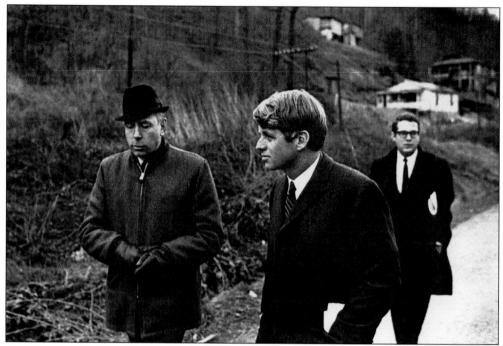

On February 15, 1968, Harry Caudill (left) accompanied Robert F. Kennedy (center) and Peter Edelman (an aide to Senator Kennedy) on a field trip to Yellow Creek in Perry County, Kentucky. The purpose of the trip was to gather research for the hearing by a senate subcommittee on Manpower, Poverty, and Hunger in America. Kennedy was assassinated a few months later, on June 6, 1968. (Courtesy of Anne Caudill.)

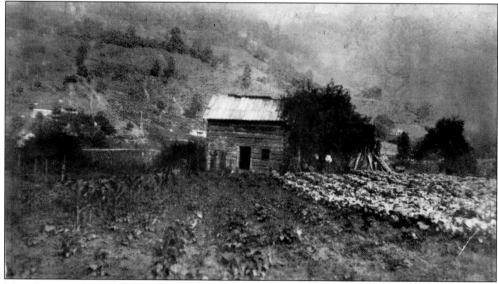

Mary Branson Caudill (Harry Caudill's maternal grandmother) was born in this cabin (built about 1810) on land that would become Blackey, Kentucky, in Letcher County. Part of the land would also become the site for the Stuart Robinson Settlement School, established in 1913. Mary Caudill recalled to family members that she saw her father and grandfather killed by Home Guardsmen in 1863. (Courtesy of Anne Caudill.)

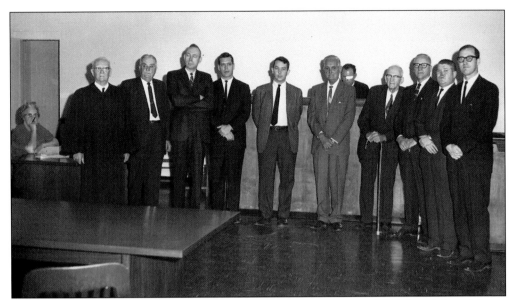

Letcher County attorneys appear in the Letcher Circuit Courtroom in 1966, from left to right, as follows: Letcher circuit clerk Majorie Adams (seated), Judge J.L. Hays, Stephen Combs Jr., Harry M. Caudill, John N. Cornett, Ronald Polly, LeRoy W. Fields, Special Judge Charles E. Lowe from Pikeville, French Hawk, Emmett Fields, F. Byrd Hogg, and Stanley Hogg. (Courtesy of Anne Caudill.)

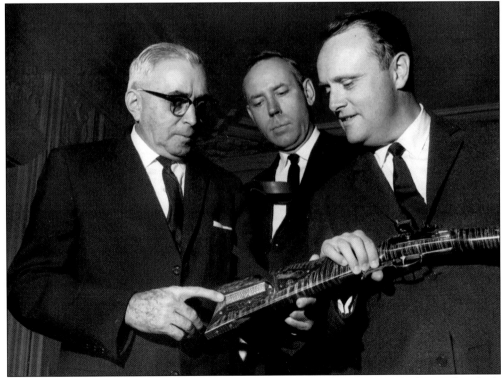

In 1967, former Letcher County judge Arthur Dixon (left) presents a Kentucky long rifle, which he made, to Governor Ned Breathitt (right.) Harry M. Caudill (center) observes Judge Dixon's craftsmanship. (Courtesy of Anne Caudill.)

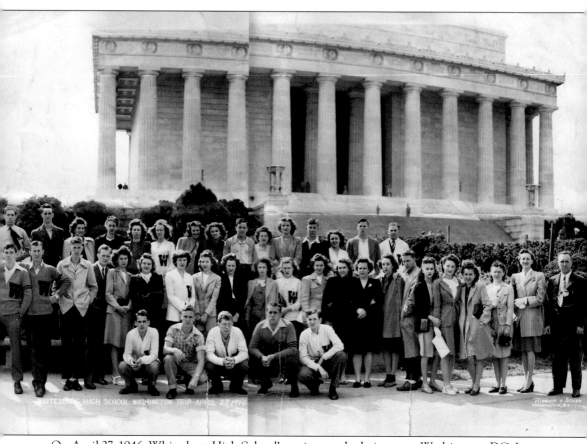

On April 27, 1946, Whitesburg High School's seniors made their way to Washington, DC. It was the first of many senior class trips. The trip-goers include, from left to right, (first row) David Neville Blair, Billy Paul Frazier, Earl Pickett Reed, James Bradley Hall, and William Ralph Whitson; (second row) Bill Rex Edmiston, Levine Fields, Harold Mason, Keith Kincer, Dimple Caudill, Ethel Marie Standifer, Joy Faye Webb, Claudia Marie Acuff, Loretta Vern Hall, Reba Jeanette Wampler, Nina Lee Jarrett, Kathryn Phyllis Back, Ruby June Adams, Betty Joe Little, Ann Hays, Fernoy Mosgrove, Naomi Jean Polly, Esther Kathyleen Hall, Betty Jo Whitson, Gwendolyn Sexton Adams, Eva Dale Stallard, and Prof. W.L. Stallard; (third row) Ed Blair, unidentified, Elline Salyer, Gaynell Blair, Valma Opal Collins, Renavae Franklin, Delma Jean Brown, Imogene Collins, Owen Adams, Velda Kincer, Ermadene Collins, Karu Ison, Rachel Combs, Charles E. Hall, and Prof. Isaac Hogg. (Courtesy of Leigh Lewis Blankenbeckler.)

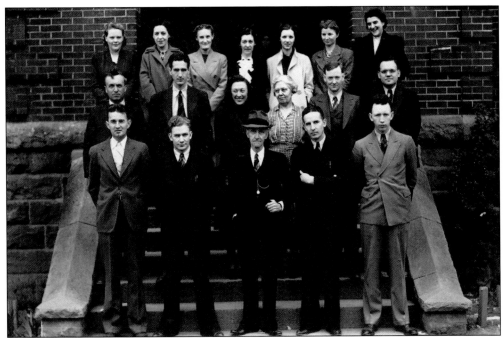

In 1939, Whitesburg High School's faculty were, from left to right, (first row) H. Dean Addington, Isaac Hogg, R. Dean Squires, Sanford Adams, and Dewan Addington; (second row) W.L. Stallard, Follace Fields, Pansy Webb, Ann Dugan, Edgar Banks, and Millard Tolliver; (third row) Maxine Frazier Salling, Dalna Hays Hale, Viola Cook, Rosa Hale Jones, Lovette Fields Brown, Cleo Stamper, and Eunice Combs Taylor. (Courtesy of LCHS.)

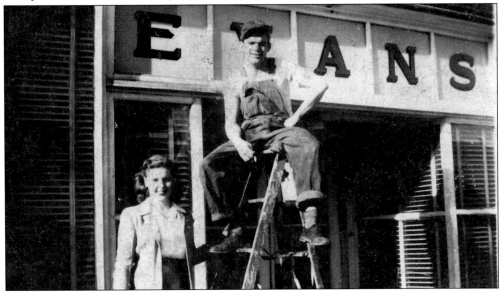

In 1947, a young Stamper Collins and his wife, Iva Lee "Red" Hall Collins, smile for a photograph in front of Dick Evans Funeral Home. Collins was an employee at the funeral home, which was located where Pigman Cleaners was for many years. He went on to establish Kentucky Tennessee Coal in Oak Ridge, Tennessee, and "Red" and her sister Angela, or "Gel," opened Duchess Beauty Shop in 1963. (Courtesy of Lee Anna Mullins.)

In 1897, county attorney Judge Ira Fields built this lovely home on Pine Street. In 1903, Fields became commonwealth attorney, serving Letcher, Perry, Bell, and Harlan Counties. Later, as districts were changed, Fields remained as Letcher County's commonwealth attorney. The home is now owned by Dr. David A. Narramore. (Courtesy of LCHS.)

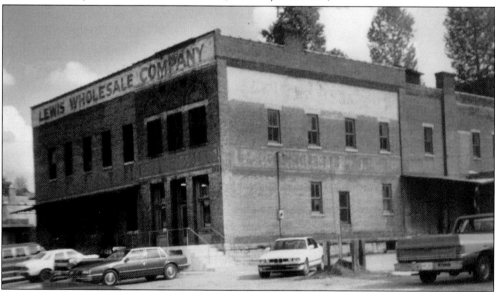

In 1892, Martin and James P. Lewis established a small business with the hardware, dry goods, and canned foods they hauled with mule teams through Scuttle Hole Gap from Stonega, Virginia. In 1909, the men established Lewis Brothers, a dry goods store, and Union Bank on Main Street, across from the courthouse. In about 1912, the brothers built Lewis Wholesale (shown), which closed its doors in 1990 and now houses the city hall. (Courtesy of Stuart Lewis.)

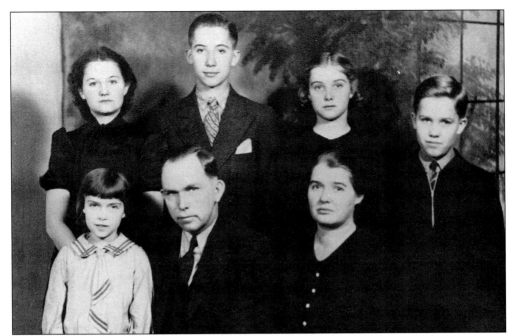

G. Bennett Adams, who was one of three students to graduate with Whitesburg High School's first graduating class in 1916, is pictured above with his family. From left to right are (first row) Ruby June Adams Caudill, G. Bennett Adams, and Ella Combs Adams; (second row) Iva Adams Collier, Steve Adams, Doris Adams Webb, and Dr. Bill Adams. Adams was elected Letcher County judge in 1949 and served as an Old Regular Baptist preacher for over 35 years. (Courtesy of LCHS.)

A young G. Bennett Adams sits atop a store clerk's cabinet, probably about 1896. The store and woman with him are unidentified. A spittoon or cuspidor sits on the floor in front of the desk. (Courtesy of LCHS.)

Prof. Henry Howell Harris is front and center in this undated photograph of the WHS faculty. Harris served as principal of WHS from 1919 to 1927 and taught for more than 50 years in Kentucky schools. There were only about 10 high school students when Harris first arrived in Whitesburg. In 1923, Whitesburg schools received accreditation. In 1924, over 100 students were enrolled in the high school. (Courtesy of LCHS.)

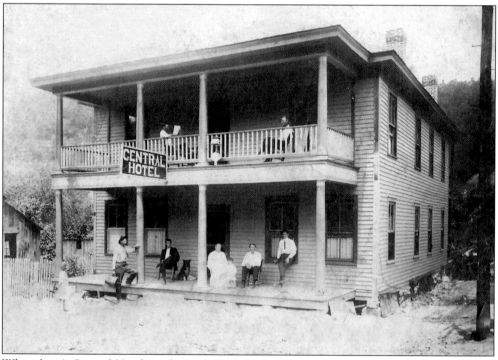

Whitesburg's Central Hotel was located on Main Street between what is now Everidge Funeral Home and the W.E. Cook stone building. (Courtesy of Don Woodford Webb.)

Parades were popular in Whitesburg during the 1950s. The theme for the 1960 Homecoming parade was book titles. A Girl Scout troop chose to make a float in honor of *Little Women* by Louisa May Alcott. These young girls are wearing bonnets and have added a spinning wheel to evoke 19th-century America. (Courtesy of Susan Day Brown.)

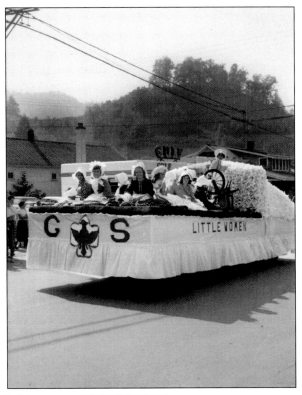

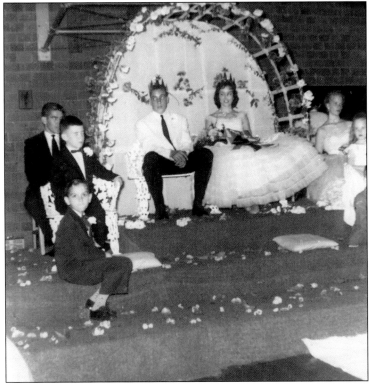

For the 1958–1959 school year, Charles Frazier and Mary Jane Rodgers were crowned king and queen of Whitesburg High School's annual Halloween carnival. One of the first carnivals to be held was in 1943, with Charles Hall and Imogene Collins elected king and queen. Traditionally, after the high school students cast their ballots, a prince and princess were chosen from each grade school class. (Courtesy of Deborah Adams Cooper.)

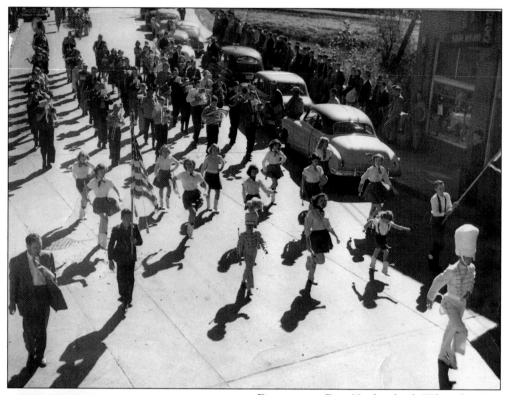

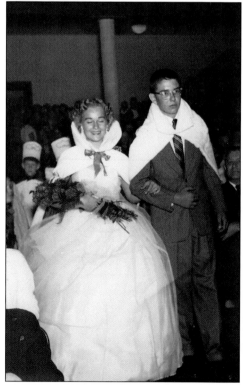

Drum major Don Hughes leads Whitesburg High School's marching band up Main Street. Phyllis Hall Adams recalls during her time as drum major that the band won the championship trophy at the Armed Forces Day Parade in Lexington. They beat Lafayette and Male High Schools. They played "Brass Band Boogie," and afterwards, Male High's band director invited Adams to join him and his band in the Rose Bowl Parade. Adams says, "What a thrill for the drum major from WHS!" (Courtesy of Phyllis Hall Adams.)

Junior class candidates Phyllis Ann Hall and Don Woodford Webb were crowned king and queen of the 1954 Halloween carnival. Phyllis Ann Hall Adams went on to serve as Whitesburg Middle School's principal. Webb and his brother, Dudley, went on to become attorneys and distinguish themselves in the real estate business. (Courtesy of Phyllis Ann Hall Adams.)

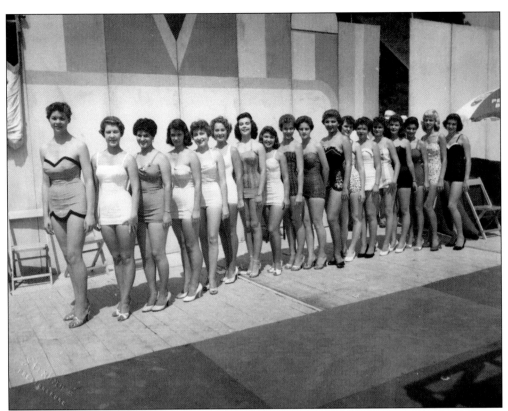

During the mid-1950s, the United Mine Workers of America decided to have a beauty pageant and recruited young women from Letcher and neighboring counties to compete. Phyllis Ann Hall competed, winning one of those years. Here she is at right with her trophy and her tiara, which was a coal miner's helmet sprayed white with a filigreed silver band around the top. The United Mine Workers of America was established in 1890 with the stated goal of representing the concerns of coal miners and coal technicians. (Both, courtesy of Phyllis Ann Hall Adams.)

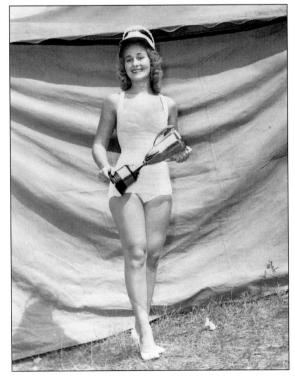

In April 1959, Cheryl Kay Frazier was winner of the district cake-baking contest. (Courtesy of Pat Yinger.)

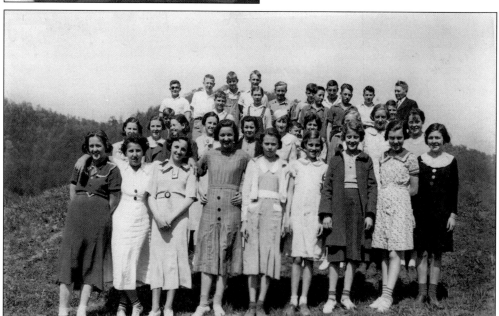

A Presbyterian Church Sunday school group includes Hazel Collins, Vashti Combs, Irene Blair, Dorothy Kilgore, Mildred Williams, Carla Winstead, Hazel Mullins, Red Craft, Fred Gibson, and Prof. Henry Harris. (Courtesy of Graham Memorial Presbyterian Church.)

The Last Black Kat newspaper related this story: "Martin Dawahare was trying to get local girls to enter a beauty pageant sponsored by the Jaycees. He talked Ann Daniel, Donelda Breeding, Janet Ison, Carol Brown, and others into entering the pageant. Ann did a monologue, 'The Yellow Wall Paper;' Janet sang 'Without a Song;' Donelda played a piano concerto; and Carol did a dramatic monologue and won the local pageant. Then Carol went on down to central Kentucky and entered the Miss Kentucky Pageant, and our beautiful mountain girl won it too. And we had our own Miss Kentucky. We were so proud of her. She went on to the Miss America Pageant and represented us with dignity and charm." (Courtesy of Phyllis Hall Adams.)

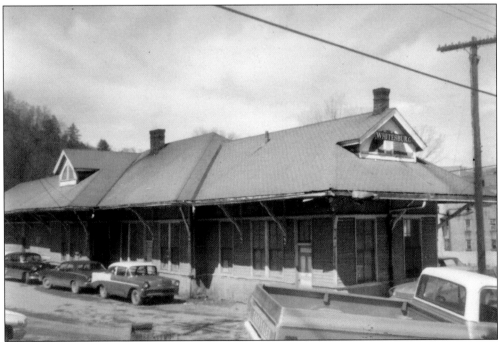

The old Louisville & Nashville depot was built by the railroad in 1912. In 1960, the railroad signed a contract with the library's board of directors to rent the depot's waiting room to the library for two dollars a year. The depot was demolished in 1970. (Courtesy of LCHS.)

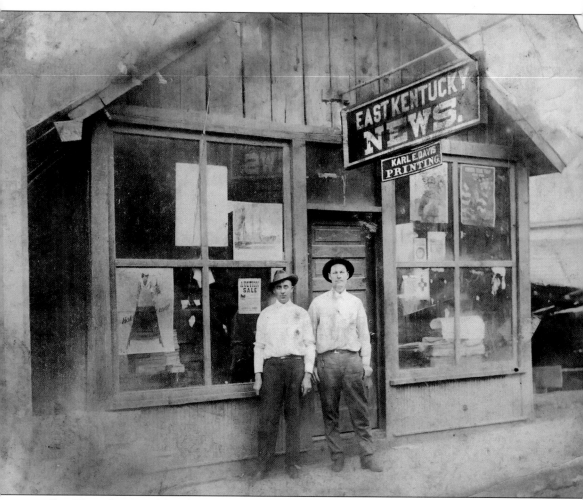

East Kentucky News (above) was published from 1911 to 1919, with Karl E. Davis as owner. Up until this time, the history of Letcher County news in print was a colorful one. In 1879, a London, Kentucky, printing outfit packed up its presses and carried them by wagon to establish the *Pound Gap Enterprise*, Letcher County's first newspaper. Tip Nickels and John Pearl were the editors and owners. The four-page, four-column paper created a sensation with its first issue. In it were wild and fanciful tales of "eyeless fish" and "moss-grown pre-historic animals." The *Pound Gap Enterprise* lasted about 15 months and moved on to Pikeville. From 1891 to 1905, there were few attempts to start a news publication. In 1905, *Letcher County News* was started, with N.M. Webb and E.P. Blair in its employ. Webb resigned shortly after and in 1907, bought what was left of the *News* to establish what is now the *Mountain Eagle*. (Courtesy of LCHS.)

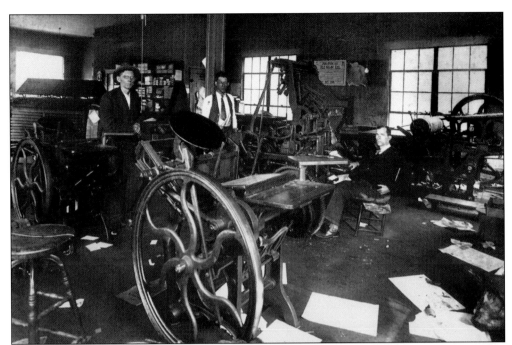

Nehemiah Mark Webb, pioneer journalist and educator, is pictured above (far left) at the *Mountain Eagle* presses in 1931. With him are J.P. Johnson (center) and F.S. Beverly (seated), a linotype operator. W. Pearl Nolan bought the paper in 1938; he subsequently sold the paper to Tom and Pat Gish in 1956. The *Mountain Eagle* has remained within the Gish family now for over 50 years. During that time, the controversial paper has won awards for investigative journalism and been particularly outspoken in the area of strip mining and mine safety. In August of 1974, the *Mountain Eagle* offices burned, and arson was alleged. According to Ben Gish, the paper's current editor, his parents continued to publish the paper from their living room and front porch. The image to the right shows Webb sitting in his rocker. (Both, courtesy of Don Woodford Webb.)

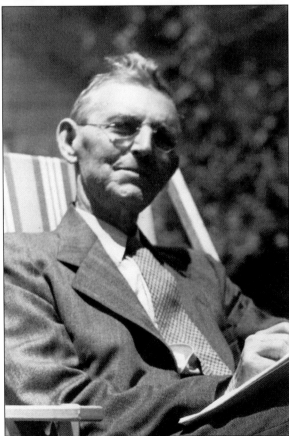

In 1940, a young Hugh Adams, band director for Whitesburg High School, parades newlywed teacher Dora (Combs) Day through the middle of town. This could have been a shivaree, a custom performed years ago to publicly celebrate a newlywed with the banging of pots and pans, loud singing, and marching through the streets. Dora Combs and McKinley Day were married in March of that year. It looks as though Adams got the students on board to add to the celebration. The wagon honoring the newly married teacher is coming from the school hill, down Cowan Street, and headed to Main Street. (Both, courtesy of Susan Day Brown.)

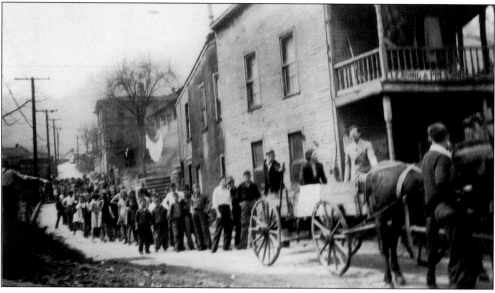

US Air Force Colonel Klair E. Back was awarded the Bronze Star medal for meritorious service while a commanding officer of the 3rd Air Rescue Squadron in the Korean conflict. Colonel Back assumed command of his unit in August 1950; he and his organization were credited with saving the lives of more than 8,200 United Nations servicemen. (Courtesy of Donna Potter.)

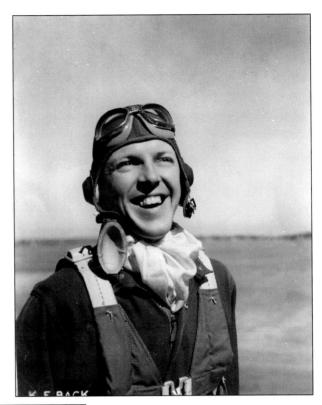

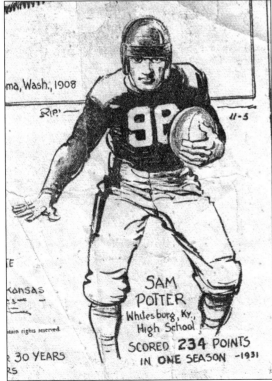

In 1931, legendary Sam Potter (left) was a member of Whitesburg High School's first undefeated football team. He received worldwide attention that year when Ripley's Believe it or Not featured him as the nation's leading football scorer. Potter went on to teach and coach at Lynch High School, where his teams won 30 consecutive regular-season games. In 1953, the *Louisville Courier-Journal* named him Coach of the Year. (Courtesy of Donna Potter.)

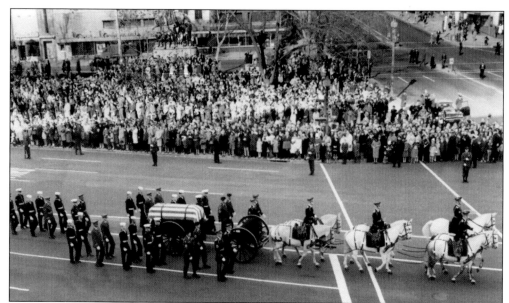

Sfc. Ben "Buster" Taylor (1928–2007), a native of Millstone, Kentucky, in Letcher County, was selected to represent his US Army 1st Special Forces Unit by escorting Pres. John F. Kennedy's caisson from the US Capitol to Arlington National Cemetery in 1964. He is pictured above, on the extreme right, between the cortege and the crowd. Taylor is pictured below, seated in the first row, second from left. He was with the 7th Special Forces Contingent (also known as the Green Berets) on November 23, 1963, in Fort Bragg, North Carolina. The sergeant first class served 14 months in Korea and performed four tours of duty in Vietnam. After leaving the military, Taylor served as sheriff of Letcher County. In 2004, Taylor established the Letcher County Veterans Memorial Museum. (Courtesy of the Letcher County Veterans Memorial Museum.)

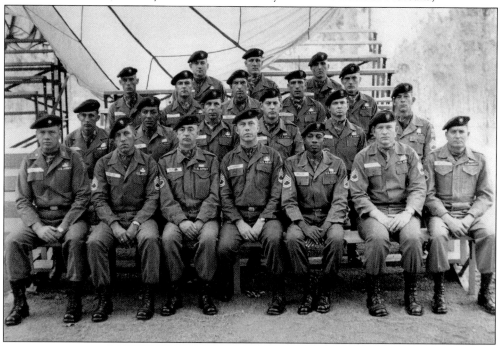

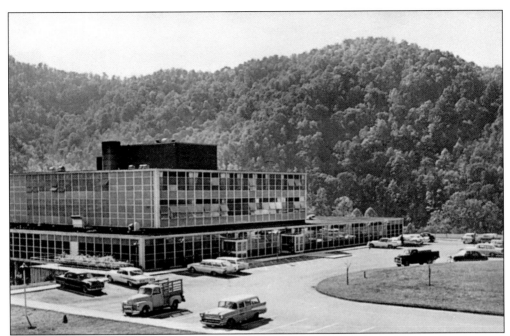

Whitesburg Memorial Hospital opened its doors to patients in March 1956. The $2 million hospital was one of 10 built in the southern coalfields by the United Mine Workers labor organization. The hospital had a staff of 161 people, including seven full-time doctors, 72 nurses and nursing assistants, and 94 beds and 23 bassinets. The hospital, in time, became independent of the UMW. (Courtesy of Deborah Adams Cooper.)

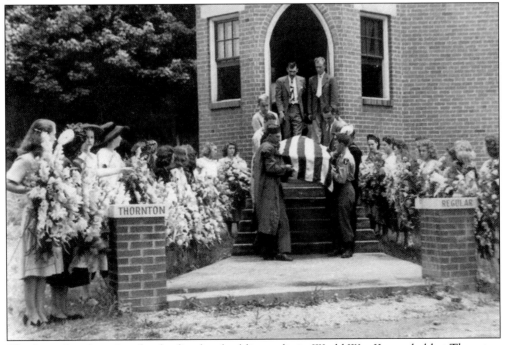

The funeral and services for the first local soldier to die in World War II were held at Thornton Regular Baptist Church. (Courtesy of Geraldine Polly Blair.)

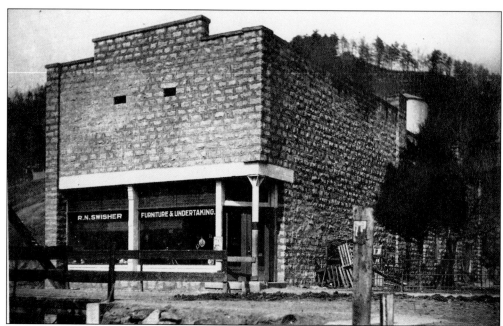

The store above is that of R.N. Swisher Furniture & Undertaking. Located approximately where the Alene Theatre used to be (and where the Fields building was), R.N. Swisher was, for several years, the only licensed undertaker and embalmer in the area. Swisher came from Richmond, Kentucky, to set up practice in Letcher County in 1912. As the story goes, the Kentucky River (which ran alongside his store) rose from heavy rains, flooded the basement of Swisher's store, and upset a large barrel of kerosene. The barrel then floated atop the swollen river. Swisher and another man were standing on the bridge next to the store watching the pool of oil. Swisher remarked, "Look at this burn," lit a match and threw it into the river. And that is what the two men did; they watched as the store, the furniture, and the undertaking goods burned to the ground. The new store building (below) still stands where Western Auto is today. (Both, courtesy of Sheila Swisher.)

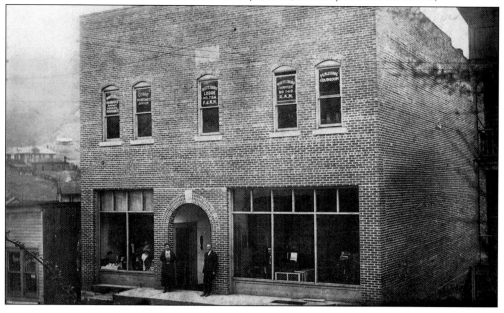

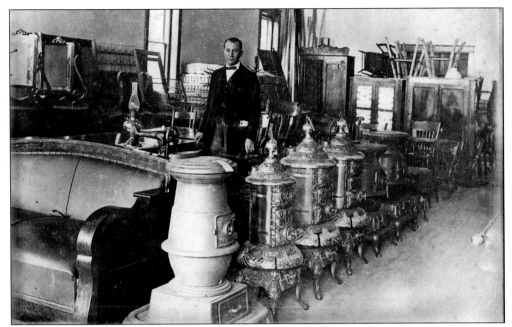

A young R.N. Swisher stands among the variety of merchandise he offered for sale in the early 1900s. On close inspection, one sees a Singer sewing machine, a kerosene lamp, and some potbellied stoves. A potbelly stove was a cast-iron, wood-burning stove with a round bulge in the middle. The bulge, somewhat similar to a portly person's potbelly, inspired the name for the stove. They were used to heat large rooms, such as one-room schoolhouses. (Courtesy of John Swisher.)

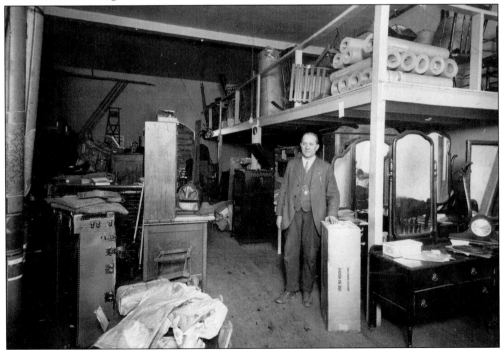

In March 1927, R.N. Swisher offers furniture that was functional and fashionable at the time, such as Hoosier kitchens, bedroom dressers, phonographs, and clocks. (Courtesy of John Swisher.)

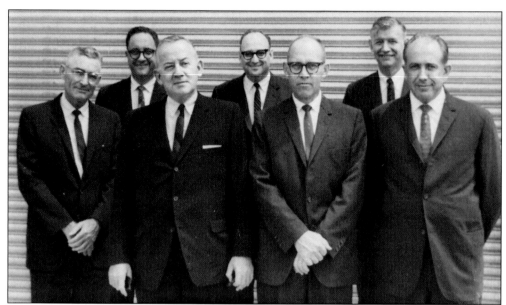

Electric and Machine Supply Company was established in the late 1940s by William F. Conley and A.W. Fields. The company specialized in electrical mine repair work and refurbishing of mining machinery equipment. Employees and members of the board of directors include, from left to right, (first row) Henry Hager, Birmingham, Alabama; George Broghamer, Cincinnati, Ohio; Jim Witt, Clarksburg, West Virginia; and William Conley; (second row) W. Melvin Adams, Willard Kiger, and Hank Ubbing. (Courtesy of Deborah Adams Cooper.)

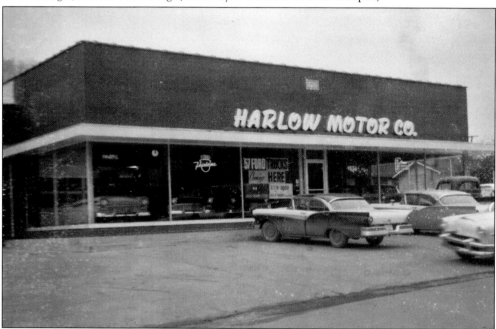

Clarance and Carl Harlow opened Harlow Motor Company on Madison Avenue in Whitesburg on October 3, 1956. The *Mountain Eagle* reported on the opening: "Two handsome Fairlane-500s and one 4-door sedan on display were soon sold and replaced by other 1957 Ford models." (Courtesy of LCHS.)

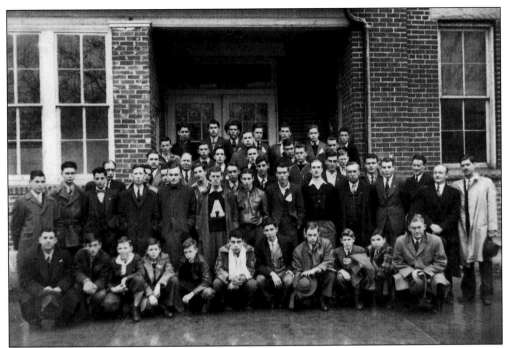

Attending the seventh annual Eastern Kentucky Conference in 1940 were 20 members of the Whitesburg Hi-Y delegation. James Frazier was the district president, and W.L. Stallard was the local sponsor. (Courtesy of Anne Caudill.)

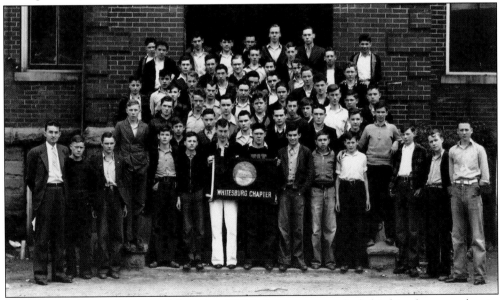

Whitesburg's Future Farmers of America (FFA) chapter was ranked third in the state chapter contest, held in Louisville, Kentucky, in August 1940. Harry Caudill, chapter secretary, was the first boy from eastern Kentucky to receive the State Future Farmer degree. Others attending this conference were president Burchett Cornett, vice president Edison Banks, treasurer Jack Cornett, reporter Lovelle Hammonds, Ulis Hunsucker, Finlay Noble, Tommy Gish, and Estill Blair. (Courtesy of Anne Caudill.)

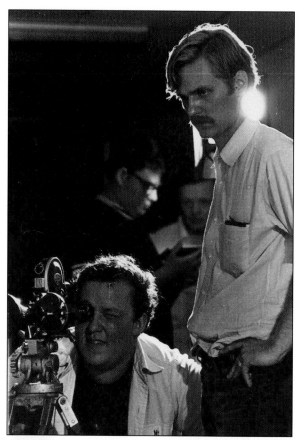

In 1969, Bill Richardson, who had worked on housing in eastern Kentucky while a student at Yale University's School of Architecture, was recruited to be the start-up director of the Community Film Workshop of Appalachia, one of eight film training centers set up across the country through grants from the Office of Economic Opportunity and the American Film Institute. Bill (pictured at left standing, with Dave Adams behind the camera and Marty Newell and an unidentified student in the background) and his wife, Josephine, moved to Whitesburg and established what would become known as Appalshop. Over more than 40 years, Appalshop has grown into a nationally recognized media center working in film, video, literature, theater, live performance, and radio. Appalshop is dedicated to preserving and documenting Appalachian traditions while promoting an understanding of the region's social and economic issues. (Courtesy of Appalshop.)

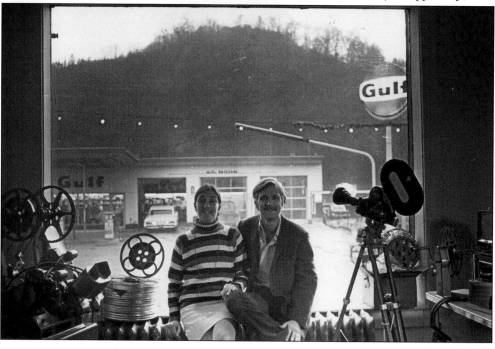

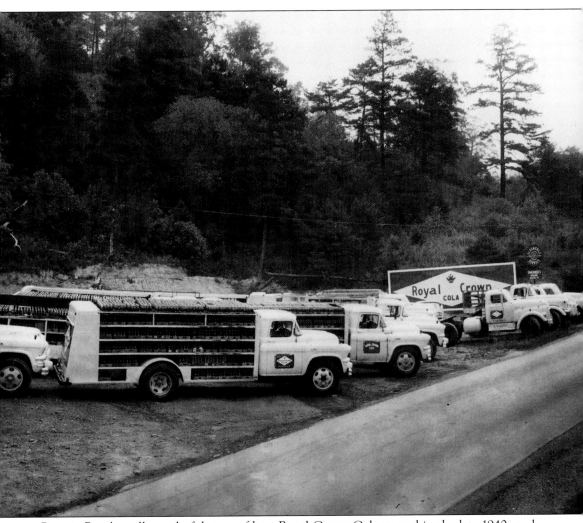

Ronnie Bentley tells a colorful story of how Royal Crown Cola started in the late 1940s and grew to work 36 routes, with around 80 trucks, at its peak in the 1960s. When Ray Collins was drafted in World War II, he sold his two coalmines on Little Collie to Brad Bentley. After the war, Collins and Bentley bought an RC Cola franchise from J.B. McAuley, of Neon. In 1947, they began bottling their only soft drink at the time, Upper 10. They delivered the Upper 10 in the two coal trucks they owned. Before long, Collins and Bentley had made enough money to build at RC Cola's current location on US 119, in Ermine, Kentucky. At one time, they delivered Royal Crown Cola, Nehi, and Upper 10 to most of southeastern Kentucky and southwestern Virginia. Collins and Bentley hosted family picnics every summer. They would end the picnic by loading all the families in the RC trucks and driving them through downtown Whitesburg. (Courtesy of Ronnie Bentley.)

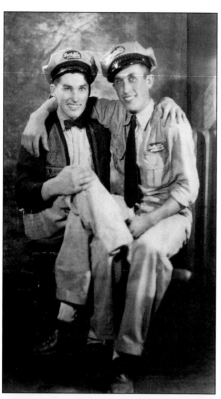

A smiling McKinley Day sits on brother Raymond Day's lap. The two worked and delivered soft drinks for the Dr. Pepper bottling company. (Courtesy of Susan Day Brown.)

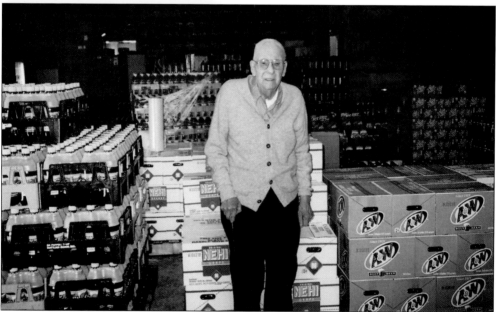

Brad Bentley (above) celebrated his 95th birthday in 2010 at the RC plant. Bentley bought out Ray Collins's concern in the business in 1965. Bentley is also known for the sign he put up 50 years ago that greets people coming into the town. It reads, "Welcome to Whitesburg, Ky. Population 1,534 friendly people plus two grouches." Bentley's son, Ronnie, says that the "two grouches" mentioned does not refer to any particular people. (Courtesy of Ronnie Bentley.)

The Senior Class of

The Whitesburg High School

requests your presence at the

Commencement Exercises

Friday evening, May twenty-fifth

at eight o'clock

School Auditorium

Dora Combs

A 1928 WHS graduation announcement proclaims the class motto as, "*Vita, lux, et intelligentia*," the class colors as blue and gold, and the class flower as a red rose. The principal was E.B. Hale and the superintendent was R. Dean Squires. Below, teachers taking in some sun on the front steps of Whitesburg Grade School include, from left to right, Oma Fields, Cora Frazier, Dora Combs Day, and Elline Salyer. (Both, courtesy of Susan Day Brown.)

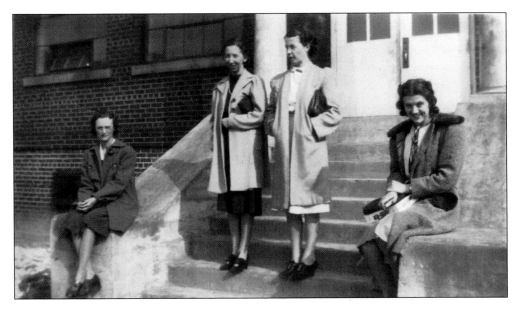

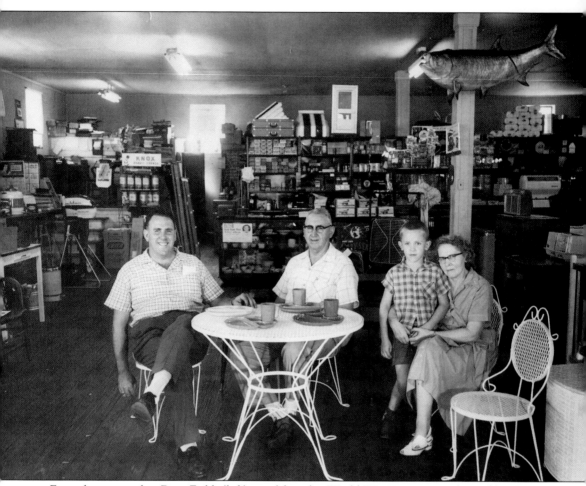

From the money that Dave Fields (left) saved from his World War II navy stint, he and his father Harrison Fields (center) opened Whitesburg Farm Service in 1948. The Whitesburg store, located at Webb Street and Broadway, sold animal feed, seeds, farming supplies, and tools. In 1965, the store advertised that it was the first and only self-service hardware store in Letcher County and changed its name to Fields Hardware and Furniture Center. It featured lines of furniture along with appliances, such as Hotpoint, Kelvinator, and Maytag. Alpha Frazier, affectionately known as "Bubba," sits at right with her arm around grandson David. For a brief time, the Fields had another hardware store on Main Street, which Bubba managed. That store was known also as Fields Hardware and was only open for a short time. The Fields closed the store in 1987. Dave Fields owned two other significant businesses: Letcher Lanes, a popular bowling alley; and Foodtown Supermarket, which he opened with Kermit Combs and subsequently sold to Combs. Foodtown Supermarket was the first grocery in the area to offer on-site parking and to feature wide, modern aisles. (Courtesy of David M. Fields.)

Three

THE COMPANY TOWNS

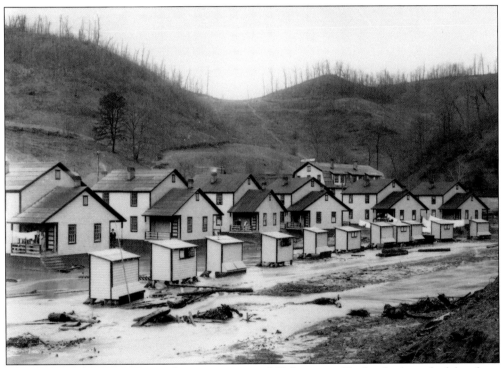

The concept of a company town has its roots in mid-19th century England, where the labor force needed to generate a specific product was organized, housed, and cared for in one place. Company housing came to America as early as industrial processes themselves. New England mill towns date to 1791. The sites for the mining of iron and the gathering of timber have determined the location for the company town. Thus, with the exception of Whitesburg, most of Letcher County's communities were formed as company towns, aimed at extracting the abundant coal that lay beneath. This photograph shows the company town of West Jenkins in 1912, with floodwaters and the Elkhorn Hotel in the background. (Courtesy of Alice Lloyd College.)

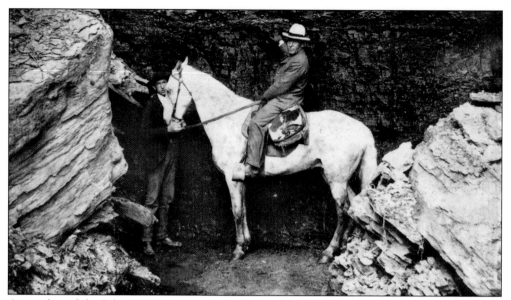

A member of the John C.C. Mayo inspection party, shown above exploring eastern Kentucky coal, demonstrates the height of a Letcher County coal seam. Below, a Potter's Fork landowner points to an eight-foot-thick seam. Mayo learned about the potential of coal from geology lectures he attended at Kentucky Wesleyan College in Owensboro, Kentucky. Mayo hired attorney F.A. Hopkins to draft the broad form deed. This deed legally allowed purchasers to buy landowners' mineral rights while letting them retain the surface rights to their property. The broad form deed became a bitter issue after 1950, when modern technology allowed for surface mining. The Kentucky Court of Appeals upheld the rights of the mineral owners from 1956 until 1988, when an amendment to the state constitution was finally approved, requiring the consent of the surface owner before surface mining could occur. (Both, courtesy of Alice Lloyd College.)

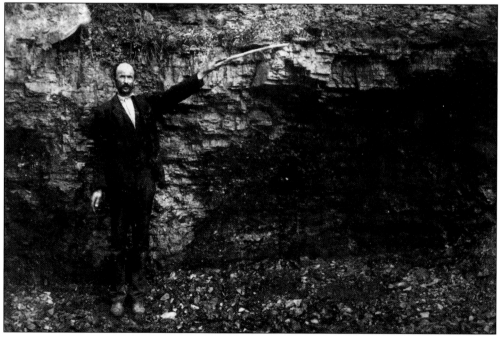

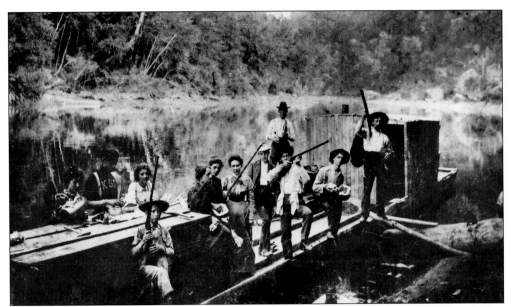

Flatboats (sometimes called push-pull boats) were the main means of transportation before steamboats replaced them in the 1820s. They were built to go downstream only, which put them at the mercy of river currents and floods. They carried timber for cabins, food, and household supplies. Over one million immigrants floated into the Ohio River Valley on these boats, sometimes with furniture and livestock on board. Because of their importance to Kentucky trade, people in New Orleans often called them Kentucky boats. (Courtesy of Alice Lloyd College.)

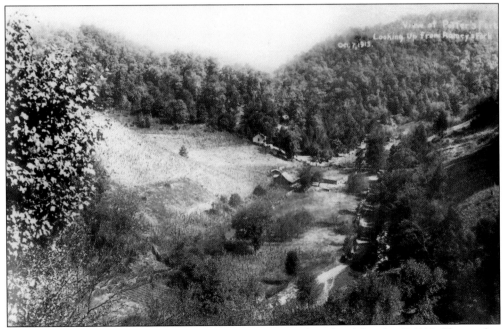

This early view of Potter's Fork, looking up from Ramey's Fork, is dated October 7, 1913. Christopher Gist and his party were reportedly the first white men to enter through the Pound Gap of Pine Mountain on the border of Virginia and Kentucky. Campsites were established here and along the North Fork of the Kentucky River in the early 19th century. (Courtesy of Alice Lloyd College.)

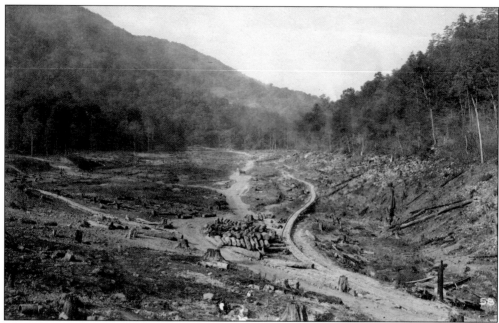

The history of Jenkins is truly unique because it was not settled gradually over a period of years, as were many other towns. The town was built specifically as a company town by men who wanted to mine the coal. A huge amount of timber and bricks were needed to begin the building of Jenkins. The wood was on the company's land, but Consolidated Coal would have to bring in the saws to process it. Temporary powerhouses would have to be built, and brickyard machinery would be needed. The nearest railroad was 30 miles away. Equipment was hauled from the mouth of Elkhorn Creek on wagons pulled by many oxen. Consolidated Coal built a temporary narrow-gauge railroad to transport supplies before building a substantial railroad west into Letcher County from Pikeville. In October 1912, the first locomotive arrived in Jenkins, Kentucky. The locomotive pictured below is hauling brick to Jenkins. (Both, courtesy of Alice Lloyd College.)

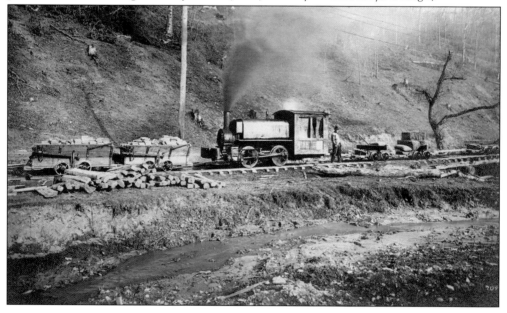

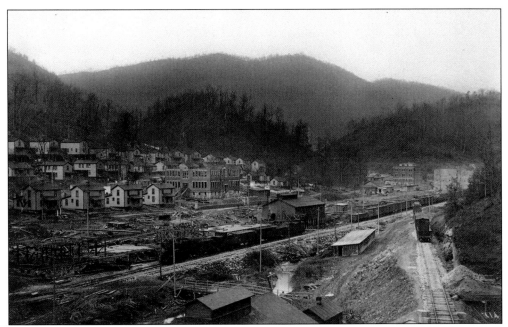

Jenkins is located in eastern Letcher County, on the Elkhorn Creek. It was the model coal company town, built in 1911 by Consolidated Coal Company, which owned 100,000 acres of coal lands in the area. The city was named for George C. Jenkins of Baltimore, one of the company's owners. Consolidated Coal originally built four towns along a seven-and-a-half-mile section of the Big Sandy Valley. Those towns of Dunham, Burdine, McRoberts, and Jenkins were incorporated in the late 1940s and had a population of 10,000. (Courtesy of Alice Lloyd College.)

A young Leona McConnell appears at Jenkins in 1917. This photograph was taken in front of the Baptist Church. (Courtesy of Linda Adams Collins.)

In a photograph dated 1910, William Henry Potter (known as W.H.) points to a beech tree with the inscription "D.B. 1781" located on the east bank of Boone Fork. In 1781, Daniel Boone was elected and took office as a representative to the Virginia General Assembly, which was held in Richmond, Virginia. The authenticity of this carving was never determined. (Courtesy of James McAuley.)

This photograph, taken in the early 1900s, shows New Kona Camp. W.H. Potter, who had initially assisted John C.C. Mayo in obtaining landowner mineral rights, refused to sell his own coal rights. Landowners were easily persuaded to sell their mineral holdings because they saw no way for the coal companies to access their coal. This was, of course, before the advent of the railroad in 1911. Elkhorn Coal Company introduced the railroad to Kona in 1917. (Courtesy of James McAuley.)

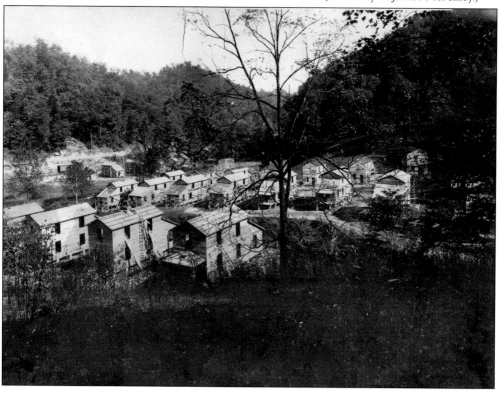

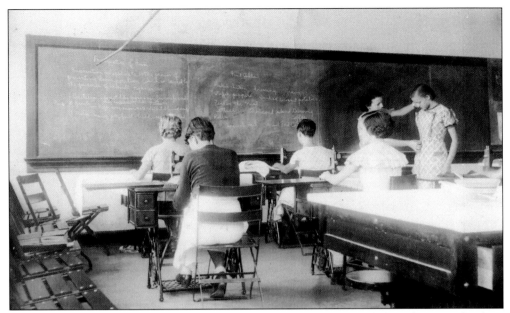

In the early 1900s, reformers from outside Appalachia began to establish settlement schools to educate mountain children and provide services for rural communities. Above is a 1920s home economics class at Stuart Robinson School, located about a mile from Blackey, Kentucky. Notable graduates from Stuart Robinson are former US secretary of commerce Juanita Kreps and Gurney Norman, a University of Kentucky professor, author of *Divine Right's Trip*, and Kentucky's poet laureate for 2009–2010. (Courtesy of Stuart Robinson School Collection, 1913–1957, Berea College Special Collections & Archives.)

The Reverend Dr. Edward Owings Guerrant (second from right) was instrumental in helping found Stuart Robinson and other schools and churches in eastern Kentucky. In 1881, Guerrant resigned as pastor of First Presbyterian Church in Louisville to pursue his interest in providing medical care to eastern Kentuckians. Guerrant graduated from Centre College in Danville, Kentucky, in 1860 and from Union Theological Seminary in Virginia in 1880. (Courtesy of LCHS.)

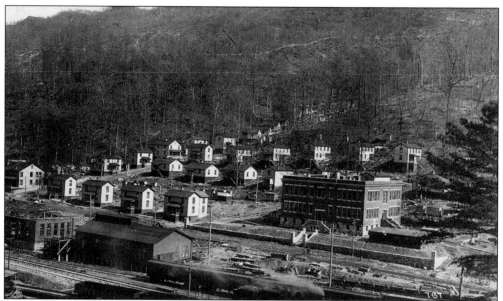

Consolidated Coal's employment relations department oversaw the town's educational facilities. By the 1930s, Jenkin's school (large building) and its system offered regular instruction and held summer classes for students on sewing, tools, and crafts. The school had more than 3,000 students in these years and hosted sports teams, a band, and a literacy program. English classes were offered to the Italian and Slavic families who had immigrated to find work. (Courtesy of Ernest Bentley.)

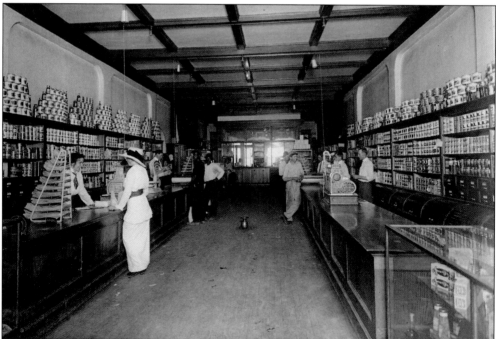

The company store was the economic and social anchor of the coal town. No mining town was without one. Because refrigeration was a rarity, women shopped for perishable items daily. This was the hub for exchanging the news and goings-on of the community. (Courtesy of Alice Lloyd College.)

Residents of Jenkins had amenities that had never been seen in Appalachia. At the Jenkins bakery (shown), many loaves of bread are on the shelves at right. The town had a YMCA, where movies were shown. Consolidated Coal fought unionization, but created an association that allowed employees to express grievances. The company paid its miners wages above the union scale and provided benefits better than other mining towns. (Courtesy of Jenkins Library.)

Shoes, scarves, purses, and gloves are on display in a 1928 Jenkins storefront. (Courtesy of Ernest Bentley.)

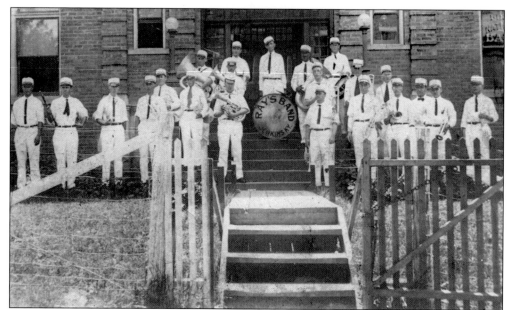

It appears that Jenkins had two concert bands in the mid-1910s. Not much is known about either band. The band pictured above is called Ray's Band. On the back of the photograph is written, "Marked left to right. ? Boggs, Marshall Gillette, ? Read. G.M. Gillette, gen. mgr. 1915." Above the heads of three men are three dark marks, possibly placed to identify the men mentioned on the back of the photograph. Pictured below is Chase's Concert Band in full uniform. (Above, courtesy of LCHS; below, courtesy of Linda Adams Collins.)

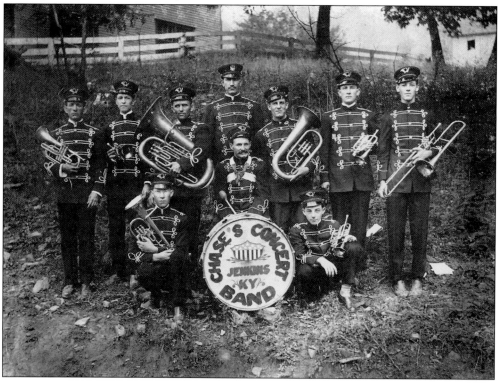

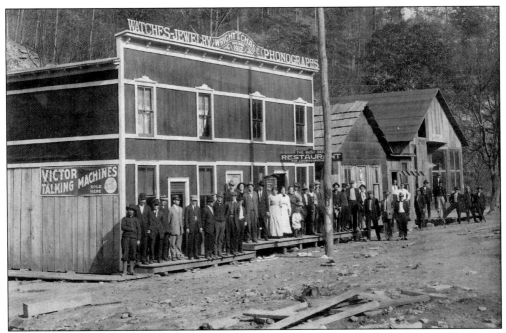

The Wright and Chase Jewelry store was established at East Jenkins in 1912. Wesley Wright was the primary owner and jeweler. A Mr. Chase worked with and co-owned the shop with Wright. They sold watches, jewelry, and Victor Talking Machine phonographs. The sign to the right of center proclaims, "The Busy Bee Restaurant for Ladies and Gentlemen." (Courtesy of Linda Adams Collins.)

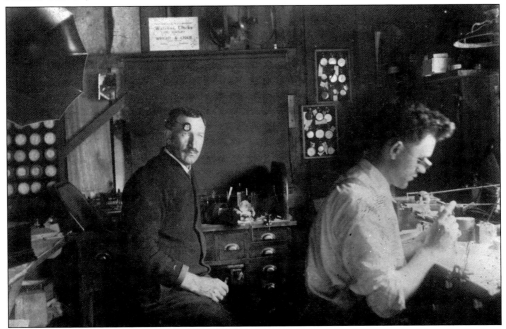

Wesley Wright (left) and Mr. Chase (right) are busily working at their jewelers' bench. A close look reveals two wallboards (right of center) that hold tagged pocket watches, possibly waiting to be repaired. (Courtesy of Linda Adams Collins.)

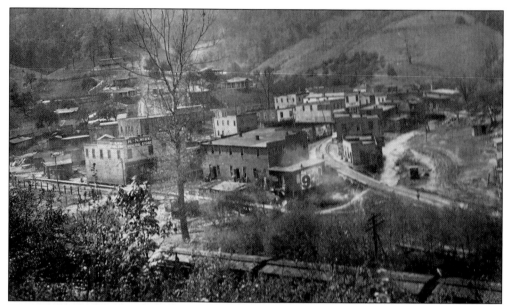

Fleming-Neon (shown in 1923) was originally two towns. Fleming was a coal town, and Neon was a trading and commercial center, which supplied goods to neighboring coal towns. The town of Neon was originally known as Chip, possibly due to the timber trade in the area. In the 1920s, the town prospered with hotels, cafes, and specialty shops. Srur Dawahare, an itinerant Syrian peddler, established Neon's most famous business, Dawahare's Department Store. (Courtesy of Linda Adams Collins.)

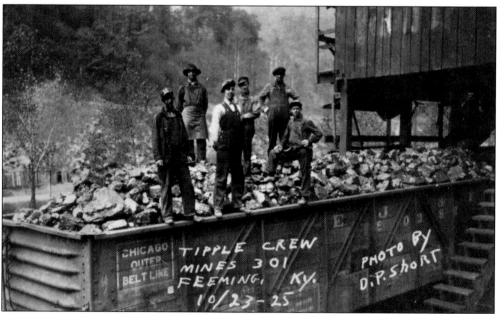

In 1925, Alfred Z. Adams (with white shirt) appears with a tipple crew. Adams started out as a coal picker, sorting coal for Elkhorn Coal Company, but decided he did not want that to be his life's work. He went to Eastern Kentucky University and learned skills that qualified him to be a bookkeeper for the company. From left to right are ? Nidiffer, William Martin, Alfred Adams, Marshall Lewis, and Osa Phipps. (Courtesy of Linda Adams Combs.)

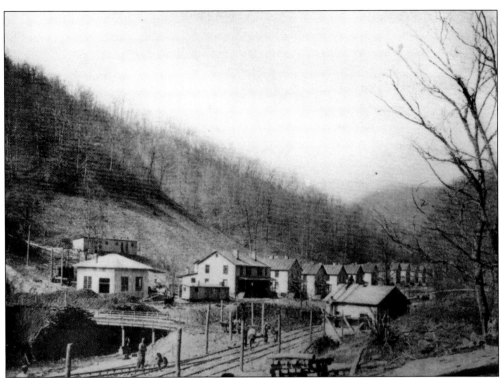

According to the Kentucky Foundation, Hemphill, Kentucky, is a coal town located one mile north of Neon and about eight miles northeast of Whitesburg. It lies at the mouth of Yonts Fork's Quillen Fork. The town was officially known as Jackhorn because the post office was established with this name in 1916. In 1920, it was named for Alexander Hemphill, a financial backer of Elkhorn Coal Company, and is known locally as Hemphill. (Courtesy of Alice Lloyd College.)

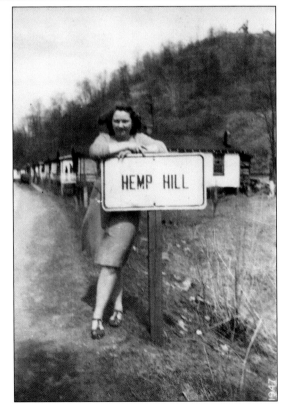

In 1947, high school student Mary Lou (Adams) Marcum leans on a sign announcing to travelers that they are now entering Hemp Hill, now spelled *Hemphill*. Mary Lou went on to study at the University of Kentucky and became a nurse. (Courtesy of Linda Adams Combs.)

In the mid-1940s, Doris Ann Fox stands behind Linda and Flo Adams for a photograph. Linda and Flo's father, Alfred Adams, owned the Pure Gas and Service Station in a place called Parson's Camp, just below Hemphill. The gas station was no ordinary gas station. Linda (Adams) Combs recalls her dad sold everything in the store, from hay, feed, farming supplies, and soft drinks, to ladies' hosiery and dresses. (Courtesy of Linda Adams Combs.)

The Hemphill Soda Fountain was the gathering place for a good meal and a good conversation. Owners A.G. and Vanessa Davis (at right in doorway) carried canned goods, groceries, and tobacco products. (Courtesy of Linda Adams Combs.)

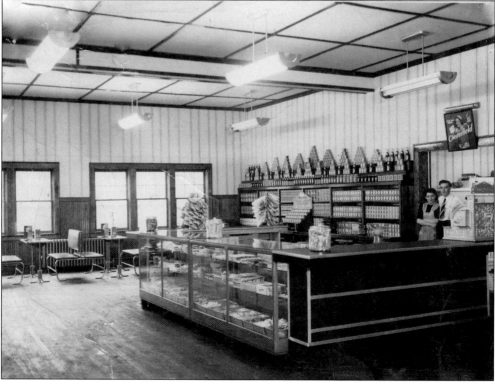

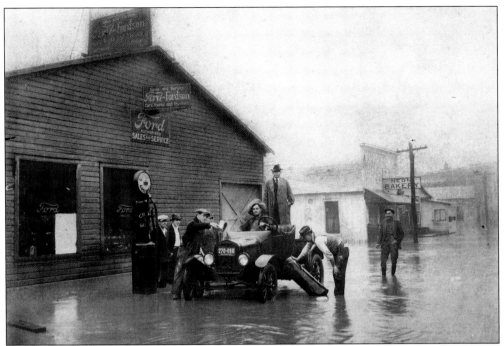

These two photographs of Neon show, to some extent, the destruction wreaked by the flood of 1927. Torrential rains began just after 11:00 p.m. on Sunday, May 29, and within minutes, coal towns were flooded. In the aftermath, 89 people were killed, 12,000 were left homeless, and men were unemployed for months as the mines where most worked had to be shut down. The *Mountain Eagle* reported on June 2, 1927, "The greatest loss of life and property was in the heads of small streams. It appears that the rain Sunday night came in cloud-burst fury, flooding the narrow gorges and trapping people before they knew what was upon them." (Courtesy of Linda Adams Collins.)

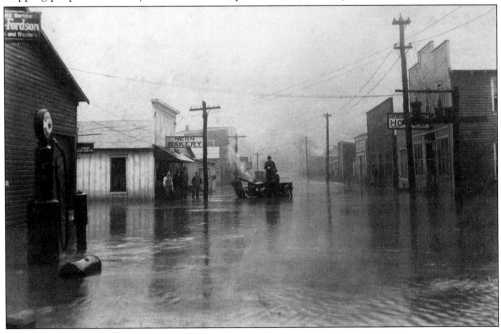

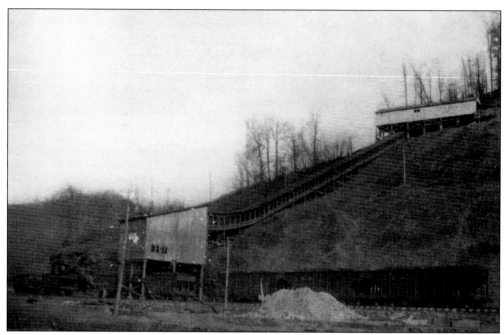

Pictured is a coal tipple that, in August 1913, loaded some of the first coal to come from Letcher County. A tipple was originally the place where mine cars were tipped and emptied of their coal. The term is still in use, but it now typically refers to the surface structures of a mine, the preparation plant, and loading tracks. (Courtesy of Alice Lloyd College.)

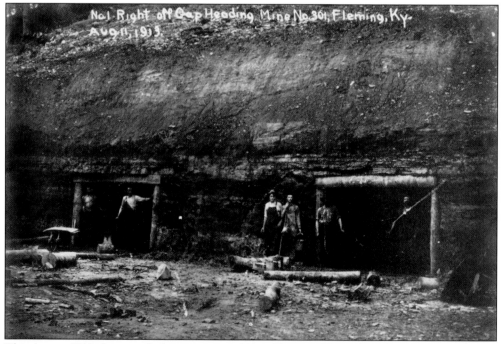

This August 1913 photograph shows mine no. 301 in Fleming, Kentucky. There are two openings into the mountain where the coal is to be mined. Timber was used to frame the mine entrances and build ceilings inside the mines. (Courtesy of Alice Lloyd College.)

Writing appears on the back of this photograph: "We all took a walk from Neon through Haymond across hill to Fleming and home." In this lively group are Willie Quillen (on pole), Mack and Stella McCoy (center), and Richard and Dee Quillen. Essie Quillen snapped the picture. (Courtesy of Linda Adams Collins.)

Willie M. Quillen was at one time police judge of Neon. He appears with confiscated moonshine. According to the *Kentucky Encyclopedia*, "when the excise tax (on liquor) became a permanent fixture, the moonshiner was nothing more than an unlicensed distiller. Refusal to pay the 1862 excise tax, however, made such distillers illegal. The moonshiner's exploits became the subject of mountain folk songs. The community often protected him from revenue agents." (Courtesy of Linda Adams Collins.)

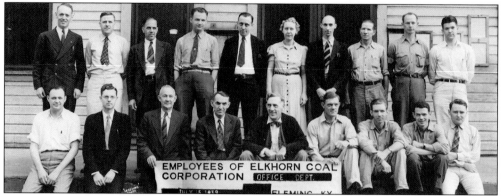

In 1939, employees of Elkhorn Coal in Fleming, Kentucky, include, from left to right, (first row) Clifford Bryant, Alfred Adams, Willie Quillen, Tracy L. Riley, Harry B. Crane, Arthur Fletcher, Edward ("Edd") McKinney, Don Poston, and Dale Christopher; (second row) William Reynolds, Alvin Kincer, Dave Kincer, Ernest Burkalow, Henry Welch, Gertie Clemonts, Malcum Dearing, Henry Adams, Howard Hill, and Charles Hix. (Courtesy of Linda Adams Collins.)

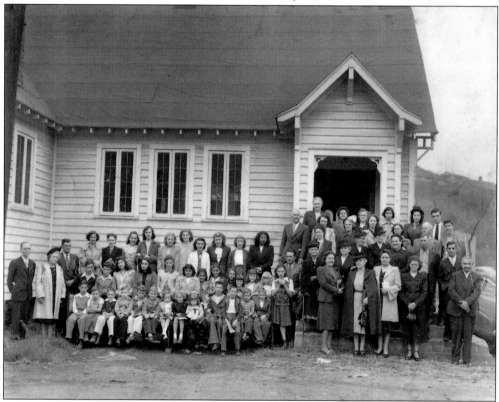

A fateful story lies behind the building of the First Church of God at Neon (pictured in 1948). The congregation found and bought an existing church building in Wolf Pit, Kentucky. It was taken down, piece by piece, and loaded into a truck to take back to Neon. On the way back from Wolf Pit, the truck carrying the church parts ran out of gas. Times were hard, and none of the workers had money. Frank Abdoo, the truck's owner, walked down the road to find help. He happened upon a $10 bill on the ground. And so they had the gas money to complete their mission. The church stands to this day. (Courtesy of Linda Adams Collins.)

Scrip, pictured at right, was a form of currency issued by the company store in the company towns. A miner's wages might be paid in scrip and once paid in that form, could not be converted back to US currency. Scrip had to be redeemed for merchandise at the company store. In his 1991 study *Coal Towns: Life, Work, and Culture in Company Towns of Southern Appalachia, 1880–1960*, Crandall Shifflett states, "Payment of wages exclusively in the form of scrip does not appear to have been common," and in no instance in Shifflett's stated study was this a "mandatory requirement." He describes scrip as "like today's credit card," saying it was issued to miners if they needed money before payday. He continues, "In spite of the miners of legend who 'owed their souls,' evidence suggests that 'debt peonage' was rare at company stores." (Right, courtesy of Deborah Cooper; below, courtesy of Ernest Bentley.)

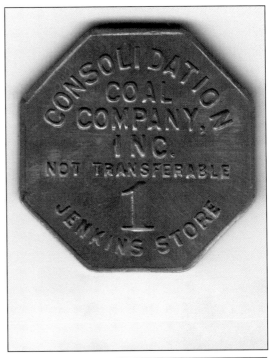

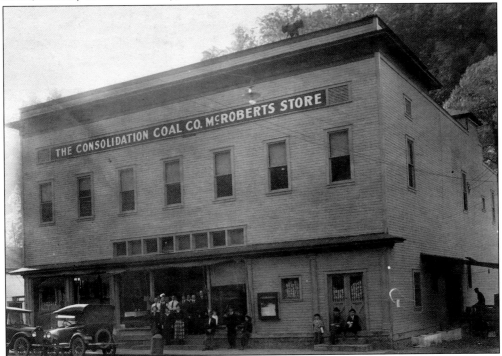

The streets of Neon were still unpaved in 1924 when this photograph was taken. The young gentleman with the tie is a Mr. Bocook, an L&N railroad conductor who died of injuries from a train. The boy on the right is unidentified. The boy in the far background on the walk is Willie Dawahare. This photograph was taken in front of W.E. Wright's store, which eventually became the Lillian Webb Memorial Library. (Courtesy of Linda Adams Collins.)

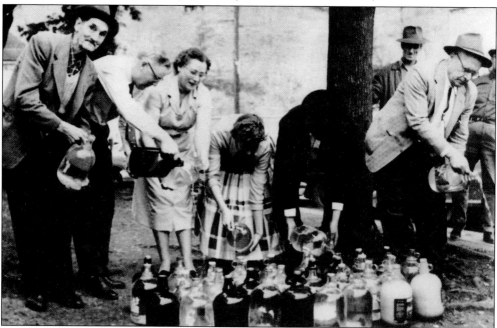

Moonshine seizures were common when this photograph was taken in 1954. On hand to help Letcher County sheriff Johnny Fulton get rid of his illegal booty are Alfred Adams, Lora Stamper, Pat Fulton, and Jim Short. In 1957, the federal government designed law enforcement procedures directed at the illegal distillers, and courts began to hand down harsher sentences. (Courtesy of LCHS.)

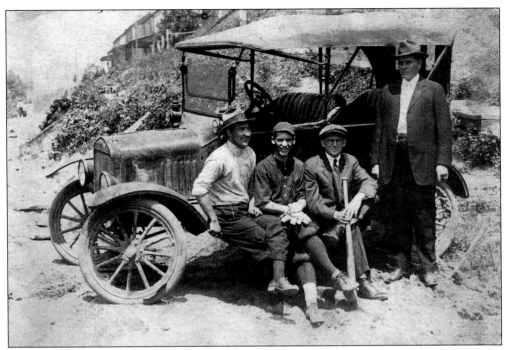

Automobiles were the backdrops for many photographs in the early 20th century. The foursome above are, in no particular order, Willie Quillen, Fattie Vance, ? McCall, and John Moore (holding the baseball bat.) (Courtesy of Linda Adams Collins.)

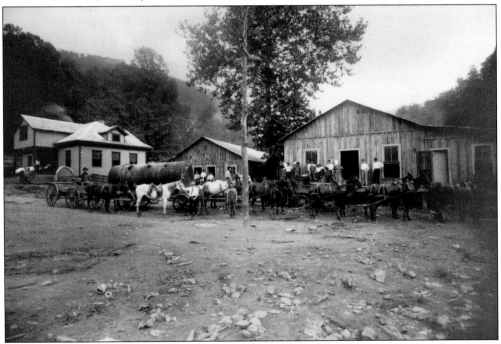

To build the town of Jenkins, much material, equipment, and supplies were necessary. Above, several head of oxen were necessary to haul a boiler over the mountains. The boiler was used to create steam for engines. (Courtesy of Alice Lloyd College.)

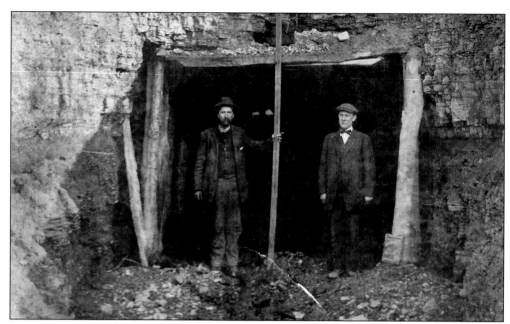

In 1914, Sam J. Wright (left) and Willie M. Quillen (right) show off the height of the coal seam on their land. Landowners in eastern Kentucky knew their coal meant money, so it was not uncommon for them to take photographs like this to show off their resources when coal company scouts came looking. This particular land belonged to Wright and his wife, Martha. (Courtesy of Linda Adams Collins.)

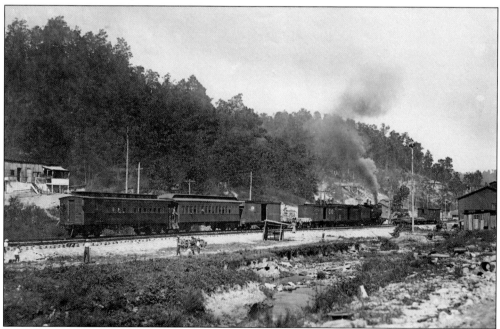

The L&N railroad pushed its tracks deep into the coalfields of eastern Kentucky with the construction, in 1911 and 1912, of more than 150 miles of track along the Cumberland River and the North Fork of the Kentucky River. Pictured is the first passenger train to enter the mountains. (Courtesy of Alice Lloyd College.)

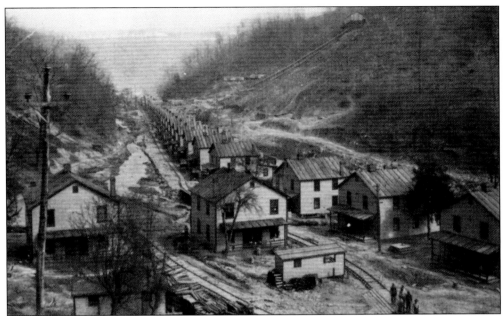

Haymond, Kentucky, was built by Elkhorn Coal Company in 1910 and named for one of its superintendents. The coal mined at this point of the Elkhorn coal seam was valuable because it was used as coking coal in steel production. The coal tipple is built on the hill in the upper right corner. The L&N railroad tracks run alongside the neat row of identical houses. (Courtesy of Alice Lloyd College.)

McRoberts lies about three miles east of Fleming-Neon and was constructed in 1912, along a spur of the L&N railroad. The L&N brought supplies to construct the town and by 1912, two circular sawmills were cutting lumber to build houses. The town featured a wide boulevard divided by a landscaped green. Most homes here were built for two families, with a water pump in the front yard and an outhouse in the back yard. Houses built for foremen, managers, and supervisors often had bathrooms, electricity, and telephones. (Courtesy of Alice Lloyd College.)

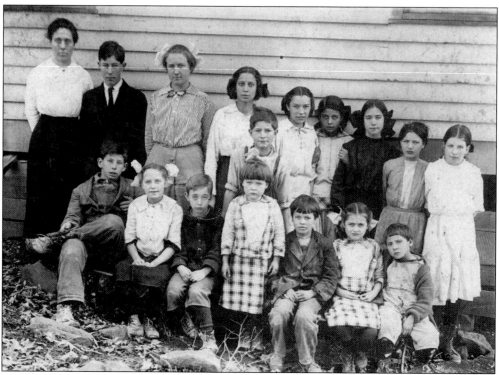

McRoberts offered an upper school and a lower school for different grade levels. Above, teacher Sara Blair stands with a group of schoolchildren. In the photograph below, children are seated at desks, and Christmas tinsel appears to be crisscrossing the ceiling. Recreation was provided for McRoberts residents. Facilities included a large ballpark, tennis courts, a theater, a soda fountain, and a tobacco and candy stand. (Above, courtesy of LCHS; below, courtesy of Alice Lloyd College.)

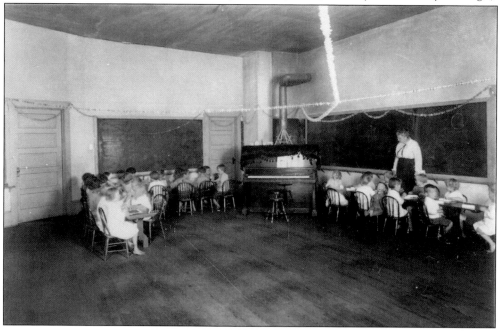

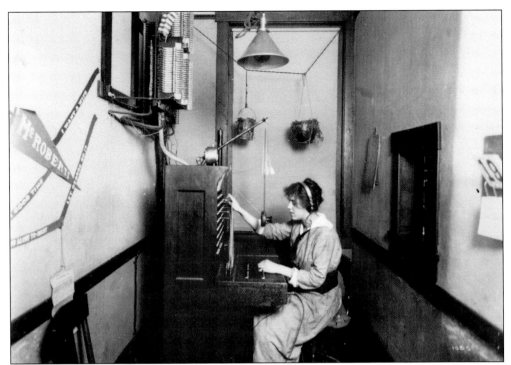

In this undated photograph, a McRoberts switchboard operator works at her desk. (Courtesy of Alice Lloyd College.)

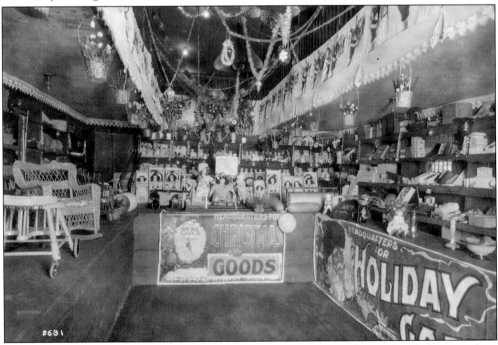

The shelves are stocked with dolls, wagons, and teddy bears in this undated photograph at McRoberts. The sign reads, "Headquarters for Christmas Goods," and features a smiling Santa holding a Christmas tree. (Courtesy of Ernest Bentley.)

On May 5, 1924, Essie Quillen and some friends gathered for a photograph with the new Jenkins hospital in the background. In 1947, Consolidated Coal divested itself of the city of Jenkins and sold its property of homes, businesses, stores, hotel, hospital, and funeral home to the residents. Consolidated Coal sold its mines to Bethlehem Steel nine years later. In 1982, Mother Teresa of Calcutta visited Jenkins and established the Missionaries of Charity Sisters to work with the area's poor. (Courtesy of Linda Adams Collins.)

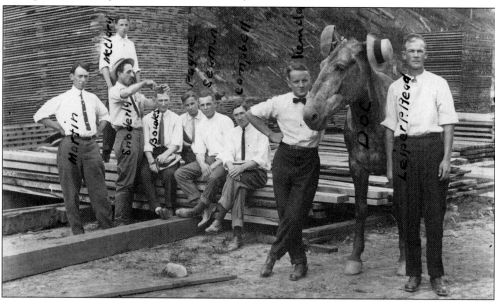

These lively gentlemen look as though they are having a good time for the photographer. They are standing in front of a large amount of lumber, possibly for building Jenkins's first barbershop. Notice they have hung their hats on the horse's ears and one funny barber is cutting the hair of his friend. As can best be deciphered from the writing on the photograph, from left to right are Martin, McClary, Snoderly, Bowles, Payne, Seaman, Campbell, Kendall, Doc, and Leiper P. Read. (Courtesy of Linda Adams Collins.)

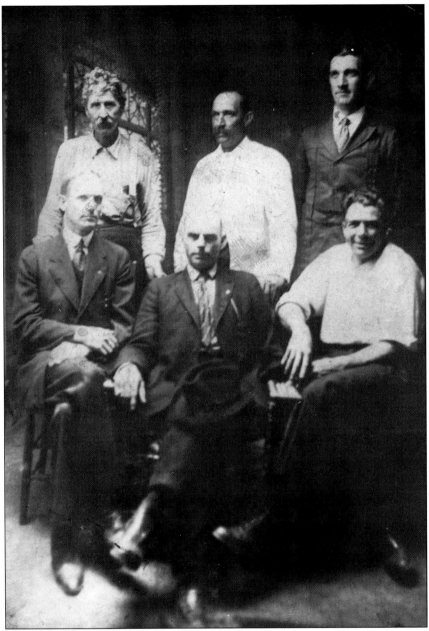

They called themselves the "Dirty Half Dozen." Pictured at Neon in 1920 are, from left to right, (first row) John D.W. Collins, Henry Garrison, and Fess Whitaker; (second row) Sam J. Wright, ? Stapleton, and Blaine Collins. Fess Whitaker (1880–1927) was a legendary and colorful Letcher County politician. Whitaker began his career in 1917 when he was narrowly elected as jailer of the county on the Republican ticket. At some point after his election, Whitaker was arrested and incarcerated for disturbing the peace and public drunkenness, thus becoming the county's only jailed jailer. Whitaker was elected county judge in the 1920s. In 1922, he was again jailed for illegally bootlegging and in 1925, was re-elected Letcher County jailer. While planning to run for a US congressional seat, Whitaker was killed in a car accident in 1927. (Courtesy of Linda Adams Collins.)

At his largest, Martin VanBuren Bates, known as the "Giant of Letcher County," was seven feet, eleven and a half inches tall and weighed 478 pounds. Born in Whitesburg in 1837, all reports say Bates was a normal size for a baby. Bates served in the Civil War as captain of the Virginia State Line Troop's Company A and retired to Cincinnati, Ohio, in 1865. It was on a trip to New Jersey to make plans for a European tour that Bates met Anna Hanen Swan, the "Giantess of Nova Scotia," who was equal to him in height. The couple is pictured alongside a normal-sized man. The couple were married in 1871 while on an exhibition tour in London. They were received by Queen Victoria on three occasions. Martin and Anna rarely toured with tent circuses and preferred to entertain guests at receptions at their farm in Seville, Ohio. The Bateses had two children, both of whom died at birth. Bates wrote an autobiography, *The Kentucky River Giant*, which told of the couple's life together. (Courtesy of Linda Adams Collins.)

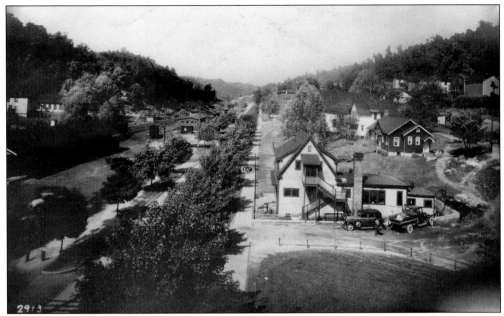

In 1930, Jenkins was a thriving company coal town. Like many other southeastern Kentucky coal towns, Jenkins reached its peak mid-century and began to decline in the 1950s. Consolidated Coal sold its properties to Bethlehem Steel in 1956. The company store, recreation centers, tipple, and other structures built by Consolidated Coal are all gone. In recent years, Jenkins Historical Foundation has tried to preserve many of the surviving buildings. (Courtesy of Ernest Bentley.)

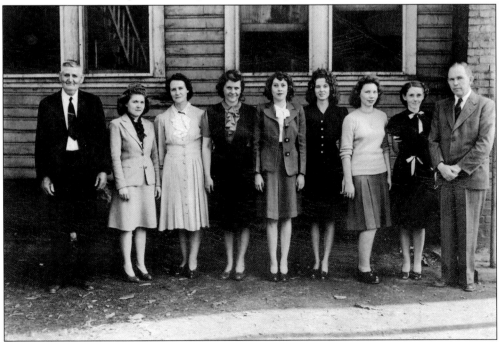

Seco's school faculty in 1940 are, from left to right, an unidentified custodian, Anna Mae Gibson, ? Banks, ? Enlowe, Sabina Williams, ? Gibson, Ola Frances Day, Elizabeth S. Mosgrove, and Rev. G. Bennett Adams. (Courtesy of LCHS.)

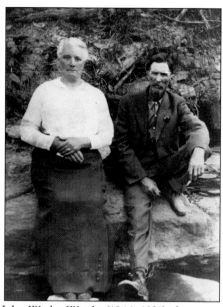

Known as "Bad" or "Devil" John Wesley Wright (1844–1931), the notorious and legendary lawman-outlaw was the basis for the character Devil Judd Tolliver in John Fox's novel *The Trail of the Lonesome Pine*. In the 1880s and early 1890s in Letcher County, there was a series of murders from ambush, mostly associated with making moonshine and bootlegging. The Talt Hall War, as it was called, involved Bad John, his best friend Talton Hall, Claibourne Jones, Dr. M.B. "The Red Fox" Taylor, and "Big Ed" Hall. Talt Hall was wanted for numerous murders, and even though Bad John was at one time sheriff of Wise County and spent most of his life as a lawman, he never arrested Hall. Bad John (pictured above, near Jenkins, and below, in an official portrait) had 31 children with several different women. Bad John served, at one time, as an agent for the Pinkerton National Detective Agency. After the Civil War, John and his uncle Martin VanBuren Bates joined the Robinson Circus where John performed as a sharp shooter. (Both, courtesy of Linda Adams Collins.)

LOUISVILLE & NASHVILLE RAILROAD COMPANY

EMPLOYE'S DIVISION TERM PASS

Nº 333710

1916

January 7th 1916

PASS ------- Dr. M. E. Hoge -------

ACCOUNT --- Company Surgeon ---

BETWEEN --- All Points on Eastern Kentucky Division ---

UNTIL June 30th 1916 *UNLESS OTHERWISE ORDERED*
AND SUBJECT TO CONDITIONS ON BACK.
VALID ONLY WHEN COUNTERSIGNED BY **THE DIVISION SUPERINTENDENT**

COUNTERSIGNED BY

SUPERINTENDENT.

GENERAL MANAGER.

FORM 26

Neighboring Breathitt County physician Dr. Mervin Eugene Hoge was considered an L&N company surgeon. Dr. Hoge graduated in 1904 from the Medical College of Kentucky, which is now the University of Louisville. He practiced family medicine in Jackson, Kentucky, for many years. (Courtesy of Janie Hoge McFadden.)

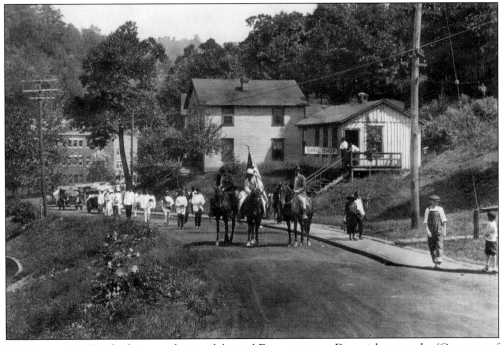

On August 8, 1924, Jenkins residents celebrated Emancipation Day with a parade. (Courtesy of Ernest Bentley.)

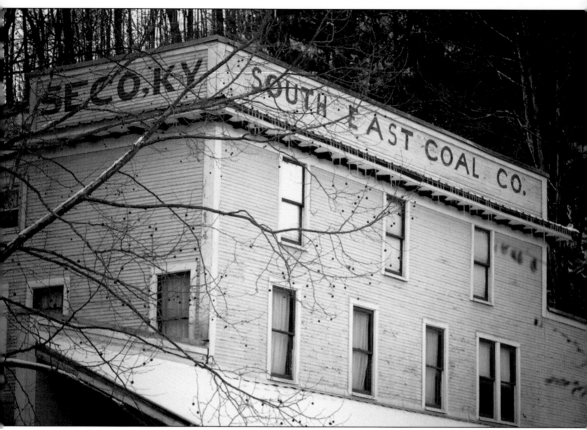

The original South East Company Store in Seco, Kentucky (shown), is thriving these days as Highlands Winery and a bed and breakfast. Jack Looney and his wife have refurbished the building; they host reunions and offer wine tastings by appointment. Loony was born in Seco and loves to tell its history. Looney says that Tom Gish, longtime editor of the *Mountain Eagle*, grew up in a house just across from the company store. Gish's mother, Lucille Gish, was known for holding tea parties every afternoon at 4:00 on her front porch. The ladies who were invited during the 1930s and 1940s wore their white gloves and chatted away the afternoon. Seco mines (the town is named after the company) operated from 1915 to 1957. When asked about the use of the controversial scrip in Seco, Looney says that Harry LaViers (one of the mine owners) told him the procedure. If the miners waited until payday for their wages, they were paid in US currency. The company deducted six dollars a month for medical fees and two dollars for housing. If the miners borrowed money before payday, they were paid in scrip and could only redeem that at the company store. (Photograph by Shonda Judy.)

Colly Creek Regular Primitive Baptist Church's contentious and conflicted history dates back to its founding in 1868. There was, at one time, a huge division of the congregation between people who believed that a person received his hell here on earth and people who believed a person received his hell at death. They were called the "hellers" and the "no-hellers." There was only one church building on Craft's Colly, and the congregation refused to meet together. They decided to make two separate entrances. The "hellers" met at one specific time, using their own entrance; the "no-hellers" met at another time, entering through their own door. Each person refused to go in the door of the other. (Photograph by Shonda Judy.)

The L&N rails that once opened up the hills of southeast Kentucky to the rest of the world are now gone in many places. In Whitesburg, the rails have been removed and replaced with paved walking paths. (Photograph by Shonda Judy.)

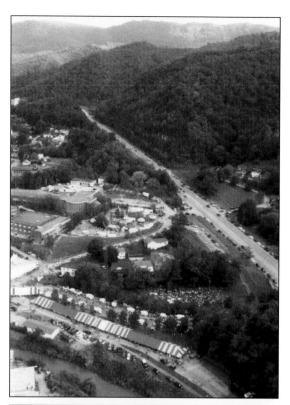

Letcher County's Mountain Heritage Festival (MHF) is a weeklong event, celebrating mountain traditions and honoring Appalachian culture. Festivalgoers can see potters creating and selling original works of art, demonstrations of weaving, broom and soap making, and even witness how moonshine is made. The MHF has been held in Whitesburg since 1982. Festival events begin the Sunday before and conclude on Saturday of the last full weekend in September. A committee of 16 volunteers organizes a carnival, food and craft booths, talent contests, live music, and a parade. In 2011, they celebrate their 29th year. (Courtesy of Mountain Heritage Festival Inc.)

Lilley Cornett Woods, located in northwestern Letcher County, is one of the largest old-growth forests in Kentucky. Lilley Cornett purchased the land that makes up the woods in the mid-1900s, and it was sold by his heirs to the Commonwealth of Kentucky in 1969. It is managed by Eastern Kentucky University and open to the public for guided tours by appointment. (Photograph by Shonda Judy.)

BIBLIOGRAPHY

Bowles, I.A. *History of Letcher County, Kentucky: Its Political and Economic Growth and Development.* Lexington, KY: Hurst Printing Company, 1949.

Caudill, Harry M. *The Mountain, the Miner, and the Lord, and Other Tales from a Country Law Office.* Lexington, KY: University Press of Kentucky, 1980.

Cornett, William T. *Letcher County Kentucky: A Brief History.* Prestonsburg, KY: State-Wide Printing Company, 1967.

Kleber, John E., Thomas D. Clark, Lowell H. Harrison, and James C. Klotter, eds. *The Kentucky Encyclopedia.* Lexington, KY: University Press of Kentucky, 1992.

Morgan, Robert. *Boone: A Biography.* Chapel Hill, NC: Algonquin Books, 2007.

Perry, Crystal. "A History of the Colly Creek Regular Primitive Baptist Church." Whitesburg, KY: unpublished paper, December 5, 1999.

Poore, William Hardin. *Stone, Mortar and Faith.* Whitesburg, KY: unpublished paper, 1942.

Richardson, Justine. "Mountain Masonry: Italians Build in Whitesburg, Kentucky, 1911–1952." Bachelor's thesis, Yale University, 1992.

Torok, George D. *A Guide to Historic Coal Towns of the Big Sandy River Valley.* Knoxville, TN: University of Tennessee Press, 2004.

DISCOVER THOUSANDS OF LOCAL HISTORY BOOKS
FEATURING MILLIONS OF VINTAGE IMAGES

Arcadia Publishing, the leading local history publisher in the United States, is committed to making history accessible and meaningful through publishing books that celebrate and preserve the heritage of America's people and places.

Find more books like this at
www.arcadiapublishing.com

Search for your hometown history, your old stomping grounds, and even your favorite sports team.